IMAGES
of America

SWARTHMORE
BOROUGH

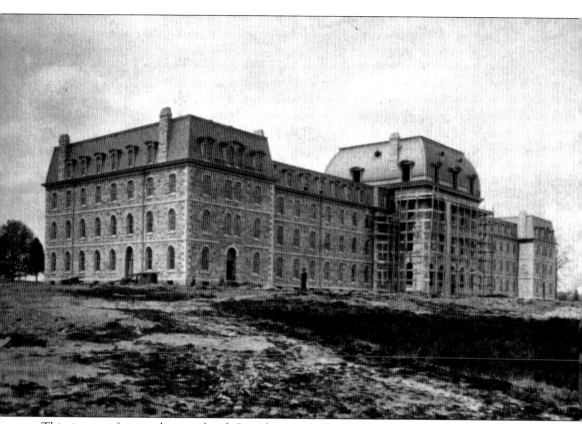

This image of a nearly completed Swarthmore College was taken 1869 by J. W. Hurn, a Philadelphia photographer and telegraph operator who aided abolitionist Frederick Douglass's escape to Canada in 1859. The image is in a scrapbook from the family of George Truman, a Quaker merchant and one of the founders of Swarthmore College. (Courtesy Friends Historical Library.)

On the cover: A train pulls into Swarthmore station, around 1895. The photograph is from an album dated June 7, 1896, assembled by Elwood C. Parry, Swarthmore College class of 1897. (Courtesy Friends Historical Library.)

IMAGES
of America

SWARTHMORE
BOROUGH

Susanna K. Morikawa
and Patricia C. O'Donnell

ARCADIA
PUBLISHING

Copyright © 2009 by Susanna K. Morikawa and Patricia C. O'Donnell
ISBN 978-0-7385-6580-4

Published by Arcadia Publishing
Charleston SC, Chicago IL, Portsmouth NH, San Francisco CA

Printed in the United States of America

Library of Congress Control Number: 2009920854

For all general information contact Arcadia Publishing at:
Telephone 843-853-2070
Fax 843-853-0044
E-mail sales@arcadiapublishing.com
For customer service and orders:
Toll-Free 1-888-313-2665

Visit us on the Internet at www.arcadiapublishing.com

CONTENTS

ACKNOWLEDGMENTS

This volume would not have been possible without the support of Christopher Densmore, curator of Friends Historical Library of Swarthmore College. We would like to thank donors and friends who contributed to the project, including Keith Lockhart, Mary Ann Jeavons, Charles Cresson, William Menke, Elizabeth Bassett, James and Ann Hazard, Bruce Lazet, George Gillespie, Alice Putnam Willets, Mary Jane Small, the *Swarthmorean*, Bob Allison, Helen Johnson, Charles and Eudora Gerner, Swarthmore Fire and Protective Association, Swarthmore Police Department, Swarthmore Borough, Swarthmore Presbyterian Church, Swarthmore Methodist Church, Irma Zimmer, Margaret Clarke Hunt and Michael J. Hathaway, Kristin Cardi, William Thomas, Paul Paulson, Betty Ann Wilson, and our supportive families.

Many of the early photographs came to Swarthmore College from the collections of George A. Hoadley, professor of physics 1888–1914; James L. Vail, class of 1896; and Isaac I. Hull, professor of history 1892–1939 and librarian of Friends Historical Library 1936–1939.

Unless otherwise noted, the images in this book are from the collections of Friends Historical Library. In addition to the papers of Quaker families and the records of Friends' organizations, Friends Historical Library also serves as the depository for the archives of Swarthmore College and of the Swarthmore Historical Society. The latter includes original materials related to the history of the borough and welcomes donations. Royalties from the sale of this volume will go toward its administration and preservation.

INTRODUCTION

The Borough of Swarthmore was incorporated on March 6, 1893, established from a section of Springfield Township. The impetus for its transformation from a rural hamlet into a thriving community with a strong self-identity came from the founding in 1864 of Swarthmore College, a coeducational college founded by members of the Society of Friends. Access to good roads and public transportation encouraged residential growth in the late 19th and 20th centuries and the development of a town center. The 21st century finds Swarthmore the home of one of the best liberal arts colleges in America, part of an award-winning public school district, and ideally situated in an area convenient to interstate highways, the airport, and public transportation. It retains its historic residential character and strong sense of neighborhood.

While the incorporation of Swarthmore as a borough in 1893 marks the beginning of the official history, its actual history begins much earlier. European settlers have inhabited this section of Delaware County, approximately one and a half square miles in area, since the late 17th century and, before that, by indigenous people of the Delaware tribe, the Lenape. The clan of the Lenape that inhabited Delaware County was known as the Unami, or "persons from down river." They lived in small villages of longhouses made from saplings and bark, hunted the prolific wildlife, and farmed crops such as corn.

The Europeans' association with Delaware County began in the mid-1600s. First to arrive were the Swedes, who established Pennsylvania's first permanent settlement in 1643 on Tinicum Island, and the hunters and trappers who followed the rivers and creeks. The Dutch held the area briefly from 1655 until 1664, when the Dutch territories in New Netherlands were conquered by the English.

In 1681, William Penn was granted approximately 45,000 square miles of woodland in the New World. That same year, Henry Maddock and James Kennerly, who like Penn were members of the Society of Friends (Quakers), received a land grant that included most of present-day Swarthmore. Henry Maddock visited the property and built a cabin (now demolished) just off Walnut Lane. In 1724, Henry Maddock's son, Mordecai, built what is known as the Benjamin West House, now on the grounds of Swarthmore College. It is the traditional birthplace of Benjamin West, America's most famous early artist. After West's death in 1820, the area near the house became known as West Dale, or Westdale. In the late 18th century, John Crozer purchased the property. His son, John Price Crozer, Chester manufacturer and philanthropist, was raised on the farm. In the 19th century, the land was sold to John Ogden, and adjacent tracts were sold to Shillingford, Linville, and other families.

In 1789, Delaware County was created from a section of Chester County, and in 1849, the nearby town of Media became the county seat. The Swarthmore area remained a largely Quaker

farming area with two local mills, Wallingford and Strath Haven, both located on Crum Creek. Chester Road (Springfield–Chester Road/Route 320) was laid out in the late 17th century. Swarthmore Avenue (Lazaretto Road) ran to the Lazaretto, the quarantine station established in Tinicum after the 1792 yellow fever epidemic. In 1808, Baltimore Pike was incorporated as a Pennsylvania turnpike, and a tiny village of sorts, Oakdale, developed at the present intersection of Baltimore Pike and North Chester Road. In 1854, the railroad arrived, bringing accessibility to this quiet, rural area.

Opportunely, in the years before the Civil War, members of the Hicksite branch of the Society of Friends began to discuss the establishment of a coeducational school for higher education. A primary concern was to provide a "guarded" education based on Quaker values. In 1860, a group of Baltimore Quakers were joined by members of Philadelphia and New York Yearly Meetings in making the decision to move forward. In early 1861, a committee was established to raise funds for the proposed institution and to select an appropriate location, near a big city so that teachers could be easily hired, but far enough away from corrupting influences.

Because of its natural resources and convenient location 11 miles outside of Philadelphia, between Baltimore and New York, the hamlet of Westdale was chosen. The school was to be named Swarthmore after Swarthmoor Hall in England, a refuge for Quakers during the persecutions of the 17th century. Although the Civil War caused a delay, Swarthmore College was incorporated on May 4, 1864.

The college opened in the fall of 1869. Soon people associated with the college or attracted to the "Friendly values" built homes on West Hill, adjacent to the young campus. In 1870, the name of the train stop was changed to Swarthmore. In 1880s, the line became part of the Pennsylvania Railroad system with expanded service. Quickly Swarthmore's location on a commuter line inspired real estate development and the subsequent growth of a small business district.

Steady residential development, including many architect-designed homes, continued into the mid-20th century. At the same time, the college thrived with its property encompassing about a third of the borough, including the campuswide arboretum and Crum Woods. The result is a green college town with a strong small-town identity and active organizations.

As noted in the introduction to the 2001 "Survey Analysis" in *Delaware County Planning Department Historic Resources Survey for Swarthmore Borough*:

> Unlike many neighboring suburban communities, Swarthmore has an uncommon built environment. Swarthmore's mix of natural elements, early suburban development, compact commercial center and fine collection of architecture makes it unique to both Delaware County and the Philadelphia area.
>
> Swarthmore has a built history that spans 300 years with an extraordinary variety of both natural and man-made features. Also well known as both a suburb and a college town, Swarthmore's residential environment and the Swarthmore college facilities are the most dominant built features of the borough.

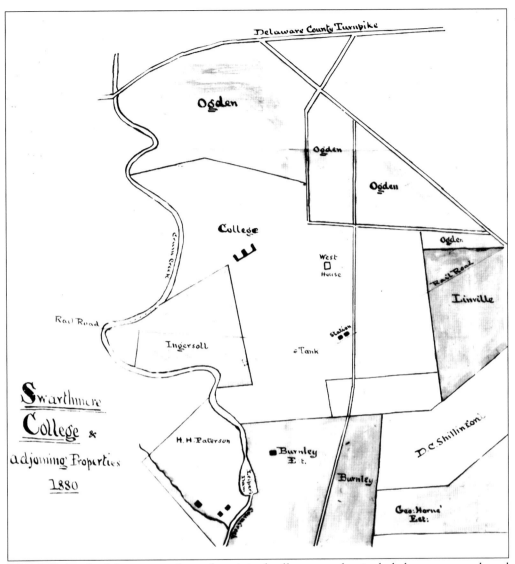

This 1880 sketch of the campus shows the original college tract that included property purchased from John Ogden and others. The main building and Benjamin West House are central. Thomas Leiper's dam and quarry buildings lie southwest of the campus. The Ogden family retained several properties north of the campus, and Linville, Shillingford, Ingersoll, and Burnley lands lay to the south.

9

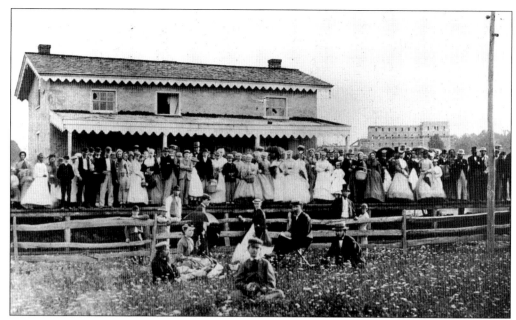

In May 1866, the cornerstone was laid for an imposing building to be set on the hill above the Westdale train station. Taken in the spring of 1867, this is the earliest known photograph of Swarthmore College, shown under construction. The original train station built about 1858 was on the north side of the tracks. The crowd was attending a reunion of Friends Lyceum, a Quaker social organization.

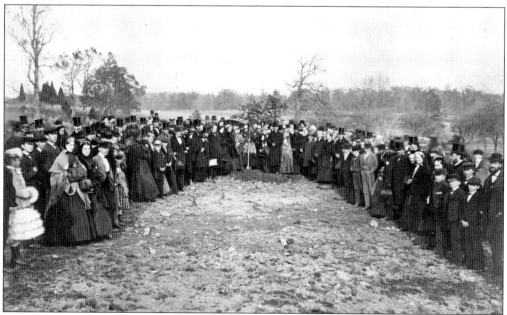

This formal photograph by Broadbent and Phillips of Philadelphia is titled "Inauguration of Swarthmore College/Planting the Trees." Lucretia Mott, influential abolitionist and suffragist, was among the distinguished Friends attending the event held on November 10, 1869. Thus began a tradition of commemorative tree planting. Swarthmore College and its Preparatory Department officially opened for classes in the fall of 1869.

One

SWARTHMORE COLLEGE

In the mid-19th century, a committee made up of representatives from three Hicksite Quaker Yearly Meetings—New York, Baltimore, and Philadelphia—selected the rural hamlet of Westdale as the location to build a coeducational college founded on Quaker values.

The Society of Friends had been founded in England in the mid-17th century. Friends, or Quakers as they are commonly known, rejected creeds, outward sacraments, and hireling ministry. They also maintained distinctive testimonies: truthfulness, simplicity, equality, and peace. These beliefs shaped the new college and continue to impact its community today.

Quakers emphasized useful learning and operated many elementary and secondary schools. A few years after an 1827 schism divided the society in the United States, one branch, the Orthodox, founded Haverford College. By the 1850s, there was a strong interest on the part of members of the other major branch, the Hicksites, to support a college as well.

The new coeducational school was to be named Swarthmore College in honor of the English Swarthmoor Hall, home of Margaret Fell, wife of founder George Fox. The American Civil War caused a delay in its implementation, but on May 4, 1864, Swarthmore College was incorporated. Land was purchased at Westdale in Springfield Township, Delaware County, so that the students might have the advantages of healthful country living and would be free of the "warping influences" of a more urban setting, according to *Friends Intelligencer*. The location offered rolling farmland, a supply of freshwater, and access to Philadelphia by train and turnpike.

By 1866, the cornerstone was laid for the imposing building subsequently named Parrish Hall. The college and Preparatory Department officially opened in 1869 with 199 students, only 25 of them actually freshmen. Within a year, Westdale, the traditional birthplace of artist Benjamin West, was renamed Swarthmore.

By 1920, the student body had grown to 500 with 64 percent from Pennsylvania. By midcentury, the school population increased to about 1,000 and became more geographically diverse. In 2009, the student body numbers almost 1,500, and the college consistently ranks among the top small liberal arts colleges in the nation.

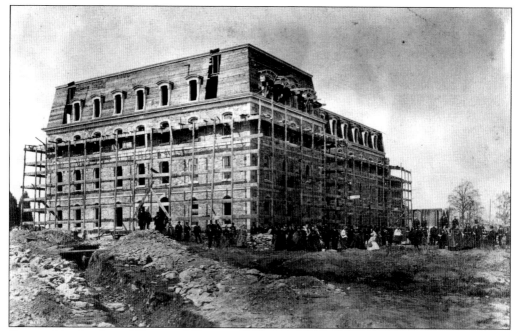

Designed by the firm of Sloan and Hutton, the first building of Swarthmore College is pictured during construction. Addison Hutton (1834–1916) was the supervising architect. The stone was cut from the quarry of Thomas Seabrook about one and a half miles away on Crum Creek. The structure was originally designed with straight mansard roofs on the wings of the building.

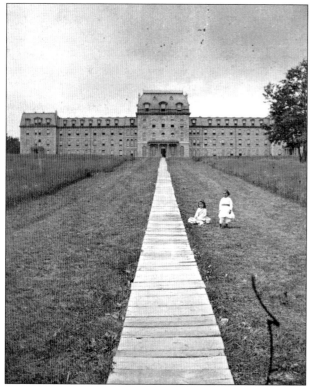

Swarthmore College is pictured shortly after completion in 1869. The roof was topped by a long widow's walk, and the front porch spanned only part of the central section. A boardwalk led up the treeless slope from the railroad station. Edward Parrish (1822–1872) was named the first president of the college in 1865. A pharmacist by vocation, his major responsibility was fund-raising.

Edward Parrish resigned in 1871 due to a conflict with the Swarthmore College Board of Managers about the mission of the college and standards of discipline. He was active in a number of Quaker concerns including the protection of the rights of American indigenous tribes. Parrish died at the age of 50 while on a mission to negotiate a treaty with the Kiowa and Comanche at Fort Sill.

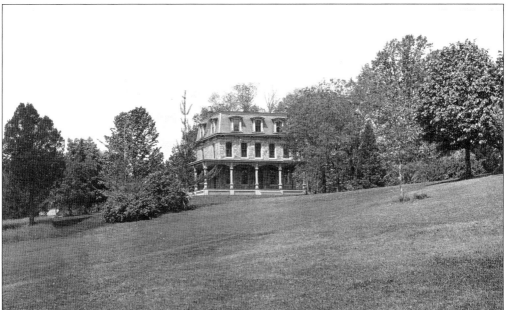

The original college president's house was built in 1874. Like the main building, it was designed by Addison Hutton and constructed of local stone in the Second Empire style. In 1911, the third floor was removed, and the building was incorporated into an observatory with funds donated by William Cameron Sproul, class of 1891, a state senator and governor of Pennsylvania 1919–1923.

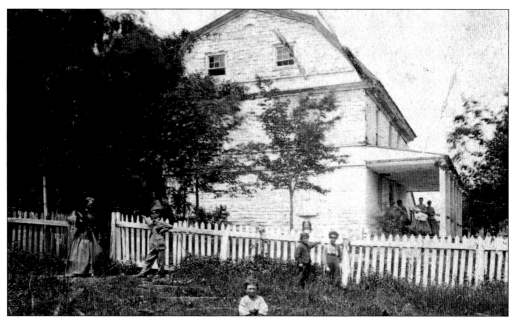

In 1724, Mordecai Maddock erected the farmhouse that is the traditional birthplace of Benjamin West, America's most famous early artist. West (1738–1820) left Pennsylvania in 1760 and became one of London's foremost painters. The house was also the boyhood home of Chester manufacturer John P. Crozer (1793–1866). This photograph was probably taken about the time of the college's 1874 purchase of the property.

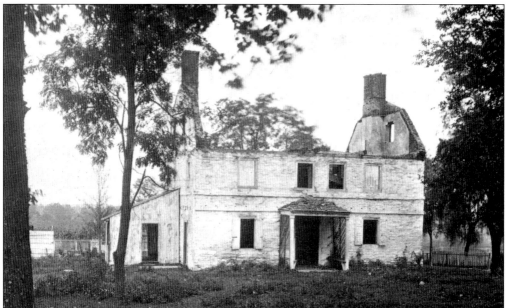

When the college was founded, it intended to maintain a working farm. The purchase in 1874 of about 50 acres known as the Westdale Tract from John Ogden created a substantial property. Ogden (1788–1877) had inherited the land from his father and expanded the family's holdings in Springfield Township. Gutted by fire shortly after its purchase by Swarthmore College, the farmhouse was restored for use as a faculty residence.

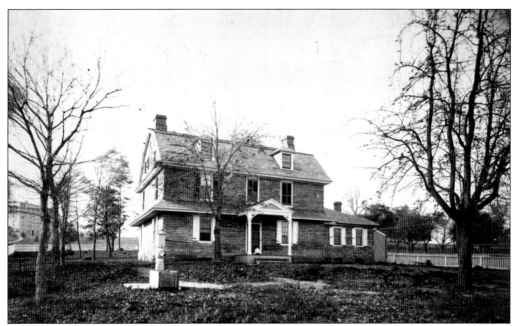

After the fire, the college restored pent eaves to the West House, and its stone walls remained unplastered. Initially, Chester Road ran past the west side of the house. It was rerouted to the east in 1878 at the request of the college, and the front facades were reversed. The house was placed on the National Register of Historic Places in 1966.

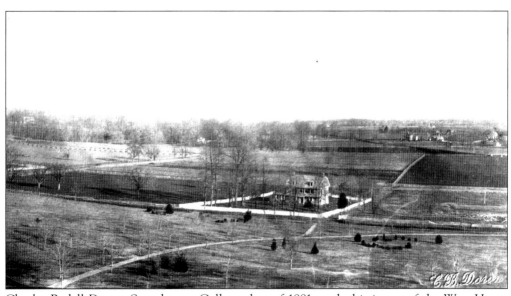

Charles Bedell Doron, Swarthmore College class of 1881, took this image of the West House and nearly treeless farmland around 1881. The photograph is from a series, "Swarthmore and Vicinity," sold through Friends Bookstore and Doron's studio in Germantown. Doron (1860–1938) subsequently worked in manufacturing and later became an osteopath.

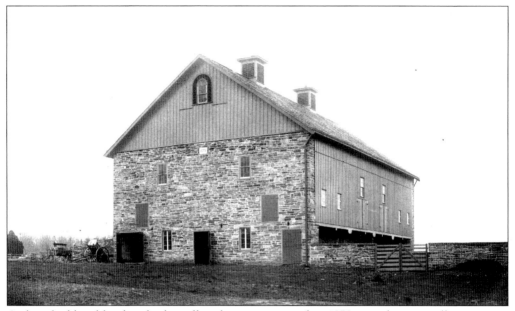

A cherished local landmark, the college barn was erected in 1879 to replace a smaller structure built in 1871. Produce from the farm fed the early student body, and an original tenant house on Field House Lane is still standing. The photograph of the west side of the barn is No. 18 in Charles Doron's "Swarthmore and Vicinity" series.

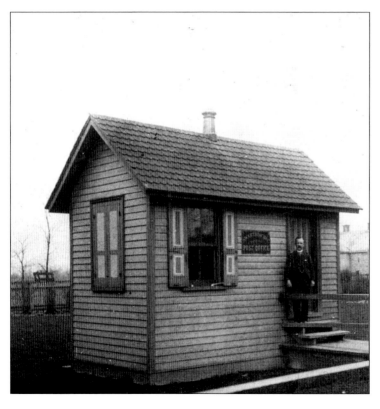

In 1871, Edward Hicks Magill (1825–1907) succeeded Edward Parrish as president of the college, balancing educational goals with stricter standards of behavior famously memorialized in his "100 Rules," published in 1883 as *Laws of Swarthmore College*. Magill served until 1889 and then returned to teaching. Part of his job description was postmaster. This picture has been identified as Magill around 1882 on the steps of the first Swarthmore post office, located beside the railroad station.

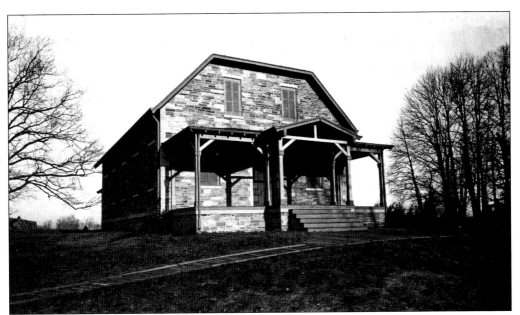

In 1878, the board of managers of the college decided that there was a need for a Friends meetinghouse as a convenient place of worship for students and faculty. A simple stone building was designed by Arthur Beardsley, professor of engineering. Joseph Wharton, prominent Quaker industrialist and longtime supporter of the college, who served on the board of managers from 1870 to 1909, donated the funds.

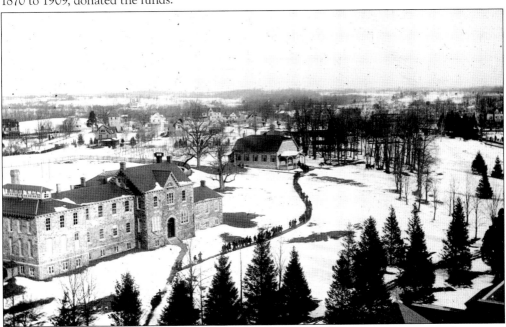

In 1881–1882, the same year that the main building was restored, the college erected a second facility, now Trotter Hall, to house the science department. Designed by Sloan and Balderston, it was enlarged over the years with a series of additions. In this photograph taken from Parrish dome, students file past Science Hall on their way to worship at the meetinghouse. West Hill houses are in the background.

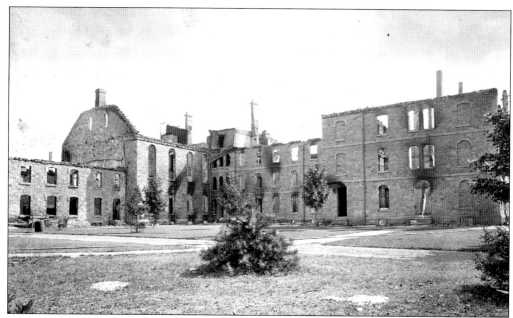

On September 25, 1881, the college suffered a disastrous fire believed to have started in the chemistry laboratory. The conflagration completely gutted the main building but left its stone walls standing. Classes continued in rented facilities in Media for the remainder of the academic year. Several plans were proposed for the rebuilding, including a Colonial Revival version with separated sections. This photograph was taken by Tyson Studio, Philadelphia.

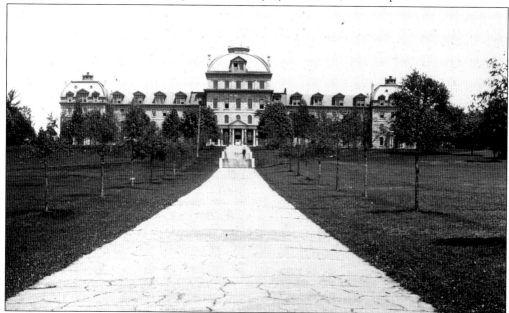

A year after the fire, the building was restored. Architects Sloan and Balderston updated the design with minor changes, primarily to the roofline that was given a more prominent central section with an unusual convex hipped roof. This view of the main building is looking north from the base of the Asphaltum, the asphalt walk laid about 1880 to replace an earlier boardwalk from the station.

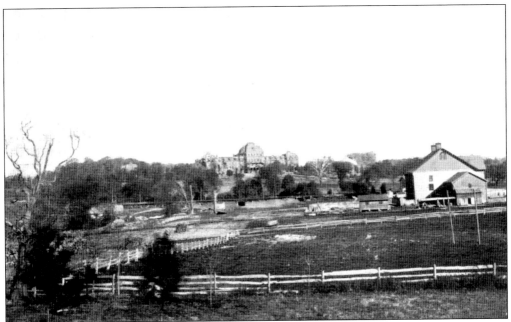

This photograph of the farm and campus from the southwest reveals the rural character of the south campus at the end of the 19th century. Photographs by George Hoadley and other members of the Swarthmore College Camera Club, especially those of James L. Vail, class of 1896, were compiled by William I. Hull, professor of Quaker history and research, for a history of Swarthmore College and were used in his popular lantern slide lectures.

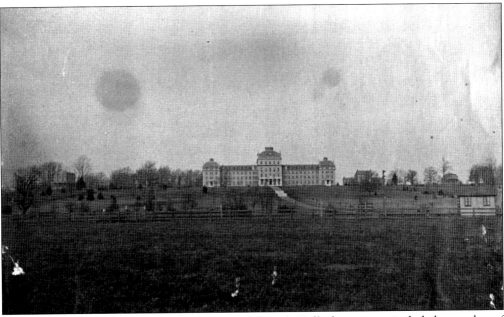

By 1902, when the main building was renamed Parrish Hall, the campus included a number of substantial structures. In this view, taken from the railroad station in the 1890s, the president's house is visible on the left of Parrish, with Trotter and the meetinghouse on its right. The building in the right foreground is the post office.

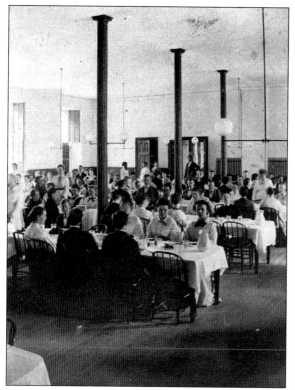

The main building originally housed all college functions including classrooms, dormitories, and library. By 1885, the number of college students was greater than students enrolled in the Preparatory Department, and by 1892, the Preparatory Department was abolished. In 1889, William Hyde Appleton briefly became president, followed by Charles De Garmo, who served from 1891 to 1898. William Birdsall served a short presidency around the turn of the 20th century (1898–1902). At left, students are shown in the dining hall in 1872. A large brass handbell summoned students; at the designated time, the doors were locked and latecomers marked as tardy. Below, in their first-floor dormitory room in 1892, freshmen Howard Cooper Johnson and E. Harper Firth invented a contraption, shown in Johnson's right hand, which enabled them to open the door of the room without getting out of their seats.

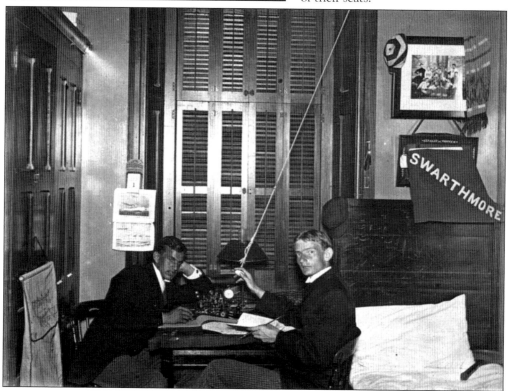

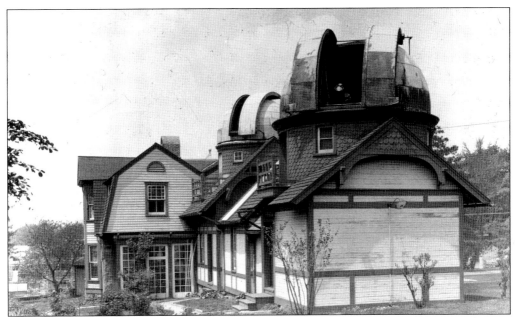

Susan J. Cunningham (1842–1921), professor of mathematics and astronomy, served on the first faculty of Swarthmore College from 1869. Her home on Cedar Lane was built in 1889. In 1892, she raised funds to build an addition to contain an observatory, the first on campus. Since 1970, the building has been the home of the Scott Arboretum.

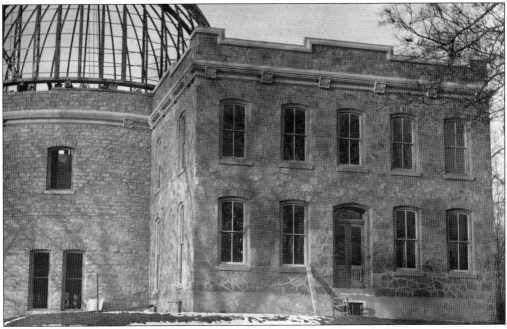

After 1909, the original president's house became part of Sproul Observatory. The new observatory dome housed a 24-inch refracting telescope that is still available for public viewing. In 1963, a second addition was constructed on the south side. In 2008, a computerized 24-inch reflecting telescope was installed in the Peter Van de Kamp Observatory in the new science center. Van de Kamp was professor of astronomy from 1937 until 1972.

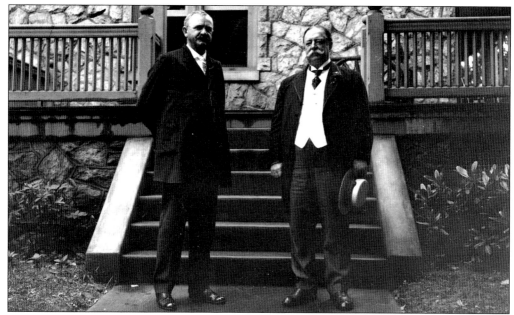

The presidency of the Joseph Swain, sixth president of the college, 1902–1921, represented the board's commitment to improving the quality of education. Swain (1857–1927), a highly regarded educator, assumed the position with the understanding that the endowment would be raised and that the presidency would hold more responsibility. Swain, on the left, is pictured with former president William Taft who spoke at the 1915 commencement on his plan to prevent war.

The north gates to the college were a gift of the class of 1889 at their 20th reunion. Morris L. Clothier, class of 1890, was the major donor. President Joseph Swain is in the center of the picture in cap and gown. Gov. William Sproul, class of 1891, is third from left. Swain's presidency was marked by a building boom that included Beardsley, Hicks, and Pearson Halls and Wharton Dormitory.

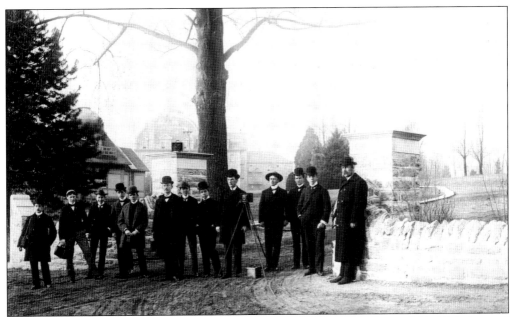

George A. Hoadley (1848–1936) was a professor of physics at the college, 1888–1914. An avid amateur photographer, he served as president of the Swarthmore College Camera Club whose members are pictured here in 1898 with Hoadley on the far right. The club sponsored an annual lantern slide exhibit. Hoadley collected early photographs of Swarthmore, and a number of his images were published in a booklet, *Swarthmore Scenes*, around 1903.

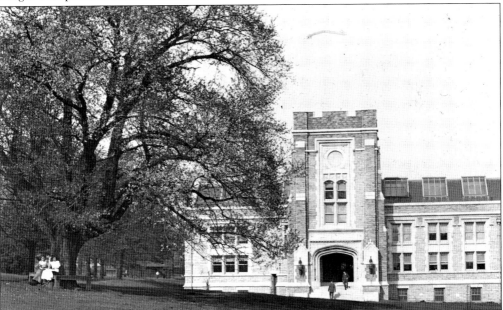

Early in Swain's presidency, the board voted to remove the requirement that board members be Quakers from the by-laws of the corporation in order to qualify for Carnegie funding. Carnegie Library was built in 1906, and in 1928 the Biddle family funded an addition to house Friends Historical Library. The building was converted into a social center after the libraries were moved to McCabe. A 1983 fire destroyed all but the Friends's addition.

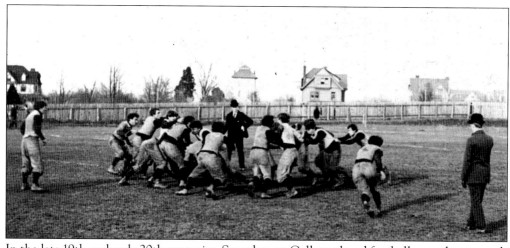

In the late 19th and early 20th centuries, Swarthmore College played football powerhouses such as the University of Pennsylvania and U.S. Naval Academy. Whittierfield, originally one word, was laid out north of Parrish Hall in the 1880s. The top photograph dates to about 1890, with the water tower and residences in the background. The bottom photograph is a detail of the 1905 team that included future professional player and prominent sportswriter Robert "Tiny" Maxwell, center, who attended Swarthmore for two years. A particularly rough game against Penn in 1905 inspired the likely apocryphal story that Pres. Teddy Roosevelt threatened to abolish football unless it was reformed. In 1907, the college rejected a large endowment from Anna T. Jeanes that carried the stipulation that it suspend all intercollegiate sports. While the football program was gradually de-emphasized, it was only discontinued in 1993.

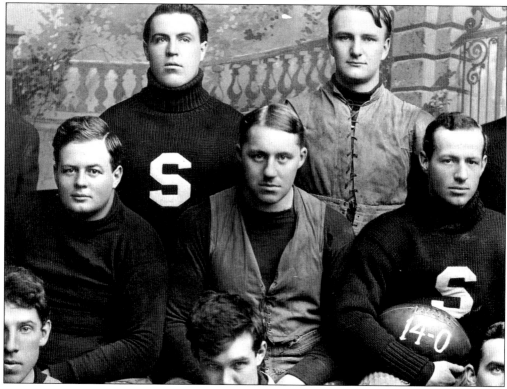

Joseph Swain retired in 1921, and his successor was Frank Aydelotte, who served until 1940. Aydelotte (1880–1956) was a Rhodes scholar and took an active role in curriculum and campus planning. Under his leadership, the college gained national prestige and economic stability and introduced the honors program. Aydelotte is pictured here with Albert Einstein, who was the speaker at the 1938 commencement.

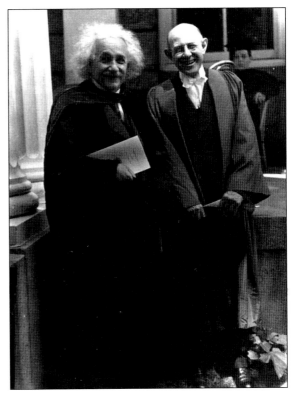

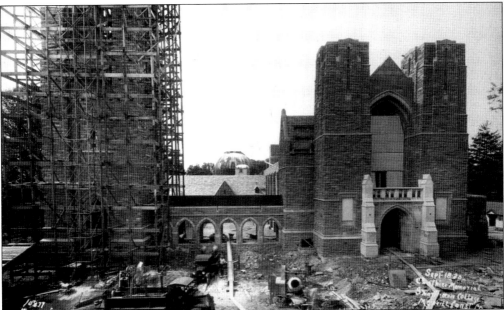

During Aydelotte's administration, a number of significant buildings were added to the campus, including Clothier Memorial, an auditorium and tower. Dedicated to Isaac Hallowell Clothier, founder of a department store and longtime board member, it was designed in the Collegiate Gothic Revival style by the firm of Karchner and Smith that was also responsible for Bond and Worth Halls and the Lodges. This photograph was taken in September 1930.

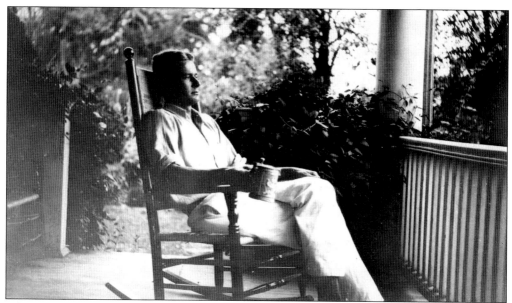

John W. Nason became president in 1940 at the age of 35. Like Aydelotte, he was a strong supporter of the honors program. Nason (1905–2001) is probably best known for his work on behalf of Japanese American students during World War II. He served as chairman of the National Japanese American Student Relocation Council that liberated more than 4,000 interned students from relocation camps and placed them in colleges and universities.

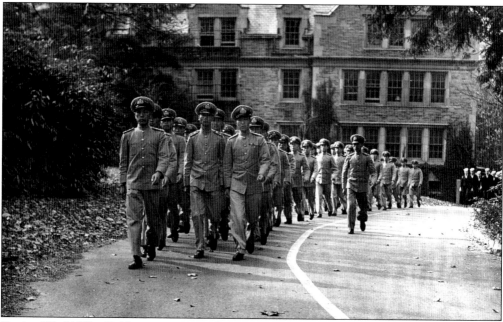

During World War II, Nason maintained enrollment by implementing a program for the U.S. Navy V-5 and V-12 units and offering continuing education to employees in local companies. In 1943, the Chinese Navy sent 49 officers to Swarthmore to study English. In the photograph, the Chinese Navy marches in front of Wharton Dormitory, with members of the U.S. Navy in the background.

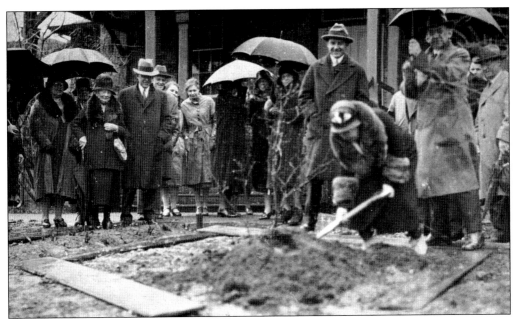

The Scott Foundation, now the Scott Arboretum of Swarthmore College, was founded in 1929 as a memorial to Arthur Hoyt Scott, class of 1895, president of Scott Paper and avid gardener. His wife, Edith Wilder Scott, is pictured in 1930 at the start of the first major planting, Lilac Walk. The cherry trees followed later that year. John C. Wister, considered the dean of American horticulture, served as director, 1930–1969.

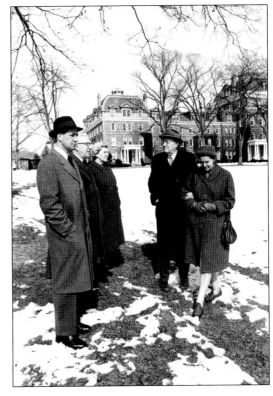

Courtney C. Smith became president in 1954. During his term, Swarthmore College flourished with increased financial stability and academic reputation. But it was also an era of great social change and tension, especially concerning social rules and increased minority enrollment. His death at the age of 52 during a 1969 student sit-in made national headlines. In this 1964 photograph, Smith (far left) and staff chat with John and Gertrude Wister.

27

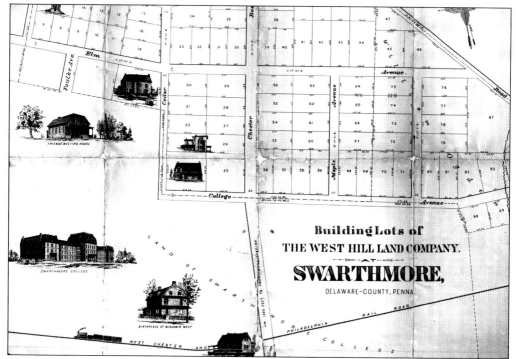

Thomas Hunter of Philadelphia produced this lithograph showing "Building Lots of the West Hill Land Company" around 1881.

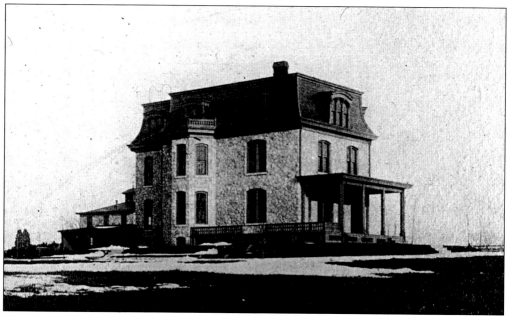

This Second Empire–style house on Elm Avenue and Cedar Lane was built in 1879 for Thomas Foulke, superintendent at the college from 1870 to 1884, and it served as a sample house for the West Hill Company. It became the president's residence in 1909 and was named the Courtney C. Smith House in 1969. This *c.* 1881 photograph by Charles B. Doron is one of his "Swarthmore and Vicinity" series.

Two

WEST HILL
LAND COMPANY

John Ogden died in 1877 with over 500 acres still in his possession. Generally bounded by the college, Crum Creek, the railroad, Baltimore Pike, and Riverview Road, this land was divided into 11 tracts. Six of his children reserved tracts for their own use. The remaining five tracts became the West Hill Land Company, Swarthmore's first real estate investment company.

Incorporated in 1878, the West Hill Land Company laid out lots on Cedar, Ogden, Elm, Walnut, Maple, and North Chester roads. Houses were to be constructed of stone or quality wood. On the board of directors were five of the six surviving sons of John Ogden: William, John W., Richard T., Charles G., and Clement. The other three investors were Thomas Foulke, Arthur Beardsley, and Thomas Walter. An advertisement for the company claimed that "the history of Springfield shows that this locality is favorable for the development of mankind—physically, mentally and morally—in the highest degree."

Early residents of the West Hill Tract, in particular J. Simmons Kent, Sylvester Garrett, Edward Sellers, and Frederick M. Simons, were leaders in developing residential tracts south of the rail line and were active in the borough's civic life.

The remaining Ogden tracts adjacent to the West Hill Tract were largely developed in the early 20th century. Most of these properties lay east of Lazaretto Road (now Swarthmore Avenue), the road that connected Baltimore Pike to the Philadelphia Lazaretto at Tinicum. The Lazaretto, built in 1799, was the first quarantine station in the United States, in operation until 1895.

Early residents on the "Hill" were mainly associated with the college or attracted to its "Friendly" (Quaker) atmosphere, but after the rail line was improved in the early 1880s, the area attracted commuters to Philadelphia. Swarthmore's location was convenient to industry in Chester and Wilmington as well. As the tracts of land became available for building, the northern part of Swarthmore continued to be residential, with many homes architect-designed, reflecting the pattern of development established by the West Hill Land Company.

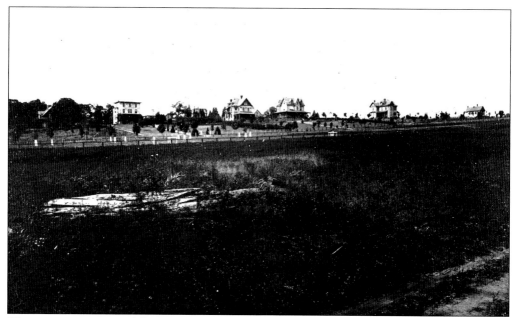

This panoramic view of the homes in the West Hill Tract between College and Elm Avenues was a one of a series of images taken by noted Philadelphia photographer Frederick Gutekunst in November 1886. The Italianate house, second from right, was built for John Simmons Kent in 1881. The next three houses were built by Frank Riggs of Clifton Heights for James Gaskill, Sylvester Garrett, and Elizabeth Sellers.

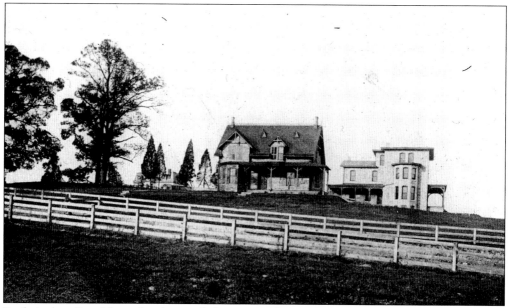

Prof. Arthur Beardsley, who designed the meetinghouse, built his home on College Avenue around 1880. Late in life, he served as curator of Friends Historical Library. In 1970, the enlarged house became the Black Cultural Center with funds provided by author James A. Michener, class of 1929. This photograph was taken around 1882, with Kent's house on the right and the West Hill sample house on the left, far distance.

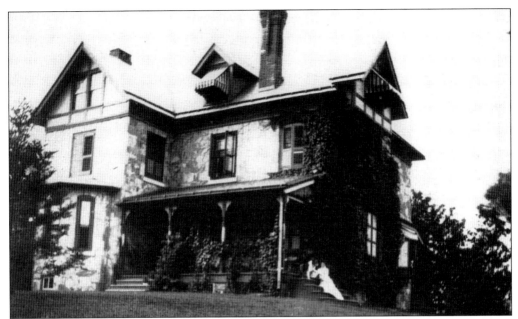

No. 405 Elm Avenue is pictured second from right on Gutekunst's 1886 panorama. In 1923, the partial width porch was replaced by a massive stuccoed porch with mission-style elements, Mercer tiles, and a second-story deck designed by William Pope Barney for Leonard C. and Ruth Potter Ashton. The Ashtons later owned 409 Elm Avenue, also built in the 1880s, which now serves as the college's guesthouse.

No. 503 Walnut Lane was designed in 1893 by Arthur Cochran, a Swarthmore graduate, in an early Colonial Revival style, albeit with a very Victorian porch. It was planned as a summerhouse for prominent Philadelphia physician Dr. Isaac G. Smedley. At the end of the 19th century and early years of the 20th century, Swarthmore had a thriving summer community with activities centered on the Strath Haven Inn. The porch was removed in the 20th century.

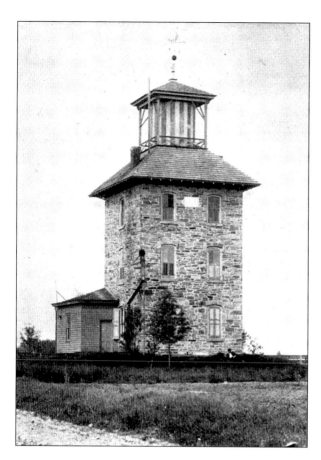

In 1881, the West Hill Land Company and several college professors built a small pumping station to supply water to the area. The group was incorporated in 1886 as the Springfield Water Company. Within a few years, the facility was moved out of Swarthmore to accommodate increased population. The Springfield Water Company eventually became Philadelphia Suburban Water Company, now part of Aqua Pennsylvania.

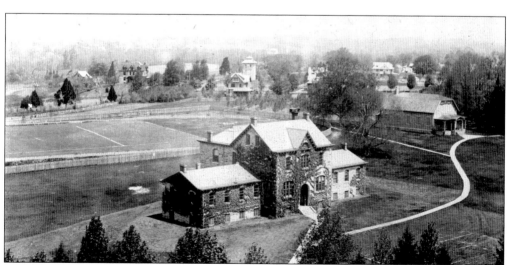

This c. 1890 view of the West Hill houses was taken from Parrish Hall, with Trotter and the meetinghouse in the foreground. At center is the water tower, converted into a house around 1900. It was later enlarged and renovated by architect Walter F. Price, brother and partner of Rose Valley architect William Lightfoot Price, in the arts and crafts style that the Prices favored.

The fine stick style house at 307 Elm Avenue was built in 1881 for Francis Sharpless and purchased by the Simonses in 1886. In 1892, they sold it to Rachel Hillborn and moved into her large house, Crumwald. After she sold 307 Elm in 1906, it went through a series of owners, including Kappa Sigma fraternity in 1920. Note the Victorian annual flower bed on the west side of the house.

Crumwald, at 402 Walnut Lane, was built around 1887 for Amos and Rachel Hillborn. The property originally extended to Crum Creek and included a carriage house. Frederick M. and Marion Simons purchased it in 1892. From 1915 to 1926, it housed the Woolman School, the antecedent of Pendle Hill, the Quaker conference center in Wallingford. A Woolman School student took this photograph in the summer of 1925.

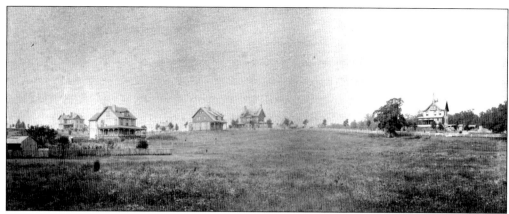

This panoramic view of the West Hill homes was taken from College Avenue by Frederick Gutekunst in 1886. From left to right, the houses are 405 Elm Avenue, 316 Maple Avenue, 416 North Chester Road on the corner of Ogden Avenue and North Chester Road (distant), 322 Maple Avenue, 307 Elm Avenue, and 213 Elm Avenue. No. 316 Maple Avenue was built for Charles G. Ogden, who sold it to William Penn Holcomb, a Swarthmore College graduate and professor.

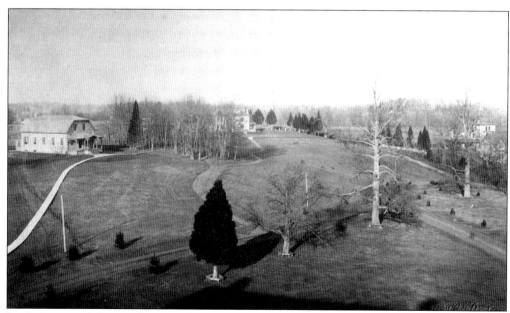

Looking toward the northeast and West Hill Tract, this photograph was taken from the top of the college by Charles Doron around 1881 for his "Swarthmore and Vicinity" series, sold at Friends Book Store and in his Philadelphia studio. Thomas Foulke's house (now the president's house) is in the center. Arthur Beardsley's home on College Avenue is barely visible on the far right.

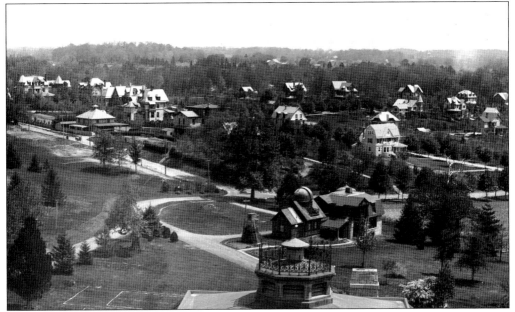

This more easterly view of the West Hill Tract was taken around 1895 from the dome of Parrish Hall. In the foreground is Cunningham House and Student Observatory, now the Scott Arboretum office. Note the observation platform set up beside the building. The house in the upper left corner, remodeled in 1925, is now Ashton House, the college's guest residence at 409 Elm Avenue.

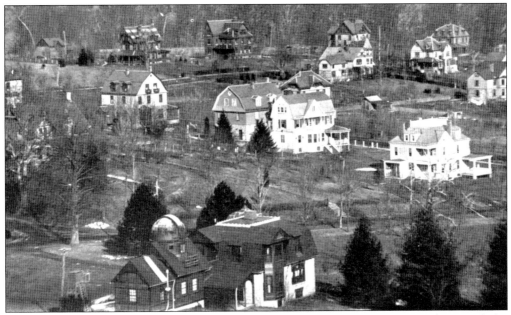

This more detailed view taken from the Parrish Hall dome just a few years later includes additional houses in the middle view on North Chester Road, namely No. 304 (corner) and the Dutch Colonial Revival houses at Nos. 306, 308, and 310. No. 306 was built by 1895, designed by Samuel Milligan, a well-known Philadelphia architect. The image was published by the college around 1900 in a brochure, *Swarthmore College, Buildings and Campus*.

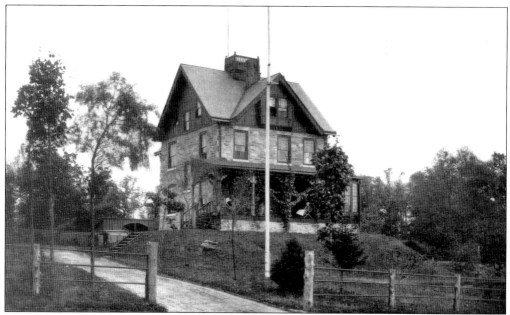

This Queen Anne–style home, Quarry Edge, at 213 Elm Avenue was constructed around 1886, one of three adjacent houses built by Dr. J. Foster Flagg. He was a prominent dentist and professor at the Philadelphia Dental School and a proponent of amalgam fillings. After his retirement from teaching in 1886, he had a dental office and operated a small dental lab in his residence. (Courtesy Mary Jane Small.)

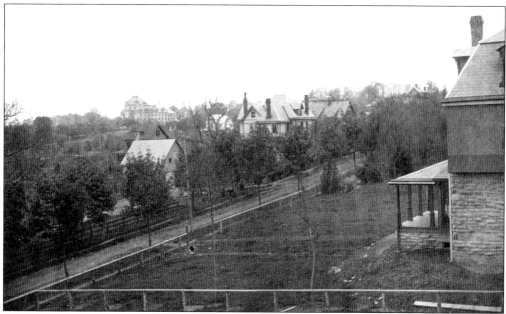

This view from across the porch of 213 Elm Avenue was photographed in 1894–1895. The house in the middle ground, across the street, was built for E. Irvin Scott and his wife around 1886. Irvin Scott and his brother Clarence were founders of Scott Paper Company. In 1902, Francis Caldwell of the firm Caldwell and Simon extensively remodeled the house. Parrish Hall is in the distance.

Previously attributed to Stanford White, the architect of the elegant Italian Renaissance–styled house at 315 Elm Avenue has recently been identified as the Philadelphia firm of Keen and Mead. The house was built in 1896 for the Torchiana family. The contractor was Isaac Walker, who also constructed Swarthmore Presbyterian Church. In 1906, the house was sold to William and Caroline Walter, both graduates of Swarthmore College. (Courtesy Michael J. Hathaway.)

No. 311 Cedar Lane, pictured in the 1920s, is an eclectically detailed Queen Anne. It was built around 1900 by Charles and Alice (Hall) Paxson, adjacent to the older and more restrained Italianate home of Alice's sister, Abbey Hall Roberts, which faces Chester Road. Charles Paxson was a stockbroker and amateur architect, and both families were active in Quaker social concerns. (Courtesy Menke and Menke.)

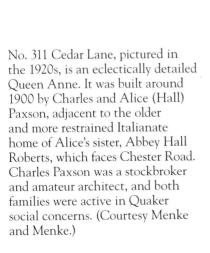

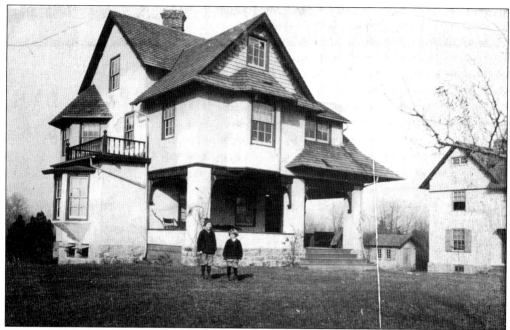

This *c.* 1905 photograph is of 5 Whittier Place, the home of Jesse H. Holmes, influential Swarthmore College professor, philosopher, and Quaker social activist. The craftsman-inspired house and its neighbor were designed around the dawn of the 20th century by his brother-in-law, William Lightfoot Price. Price (1861–1916) was the moving force behind the founding of an arts and crafts community in nearby Rose Valley in 1901.

This photograph was taken from the college's water tower near Crum Woods around 1915, looking northeast. In the foreground are the backyards of 1, 3, and 5 Whittier Place. No. 1 Whittier Place was built in 1884 for Samuel Green, professor of physics and chemistry, and his wife. The large house, right center, visible behind the Whittier Place faculty homes is the college president's residence on Elm Avenue and Cedar Lane.

This distant view of the college and West Hill was taken from the windmill at Hedgleigh Farm in 1898. The Cresson farm is in the foreground south of the railroad, and college fields and the Garrett tract, bound by Elm and Chestnut Avenues, are on the north side. Sylvester Garrett built family homes at 29 College Avenue and 228 Garrett Avenue. (Courtesy Charles O. Cresson.)

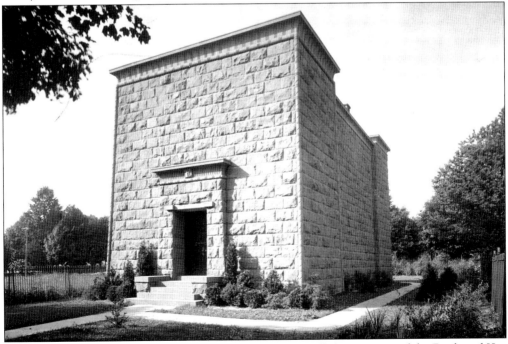

An empty lot bounded by an iron fence on Elm Avenue is all that remains of the Book and Key clubhouse, an anomaly in the residential West Hill Tract. It was built in 1907 for Book and Key, a Swarthmore College men's secret honor society modeled after Yale's Skull and Bones. The society was discontinued in the late 1950s, and the building was demolished in 1967.

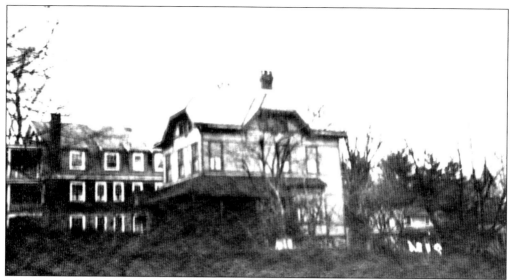

These two photographs of the same house reflect changing taste as fondness for Queen Anne–decorated facades and wrap-around porches gave way to the simple lines of mission-inspired and other 20th-century styles. The house at 315 North Chester Road was built about 1888 as a typical stone and frame Victorian. Edward M. and Frances Simons Bassett purchased the house in 1912. Below, in 1925, it was remodeled by architect William W. Price to "modernize" its look with a simple stucco exterior and arts and crafts design details. The eclectic Dutch Colonial Revival–styled stone and shingle structure on the left in the early photograph is one of Swarthmore's earliest apartment houses, built around 1903 for Albert N. Garrett. Originally named the Fenwick, it is more popularly nicknamed the Barn by Swarthmore College students.

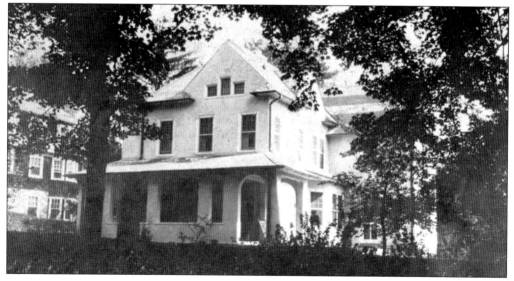

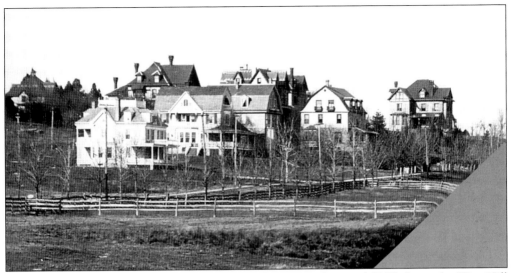

This view, taken from College Avenue toward Chester Road around 1905, shows the West Hill homes from 317 North Chester Road to 405 Elm Avenue, far right. The rear of the Fenwick is at center. Partially visible behind these houses are 318 North Chester Road and 404 Elm Avenue. The image, with a distorted right edge, is part of Prof. George Hoadley's lantern slide collection. (Courtesy Menke and Menke.)

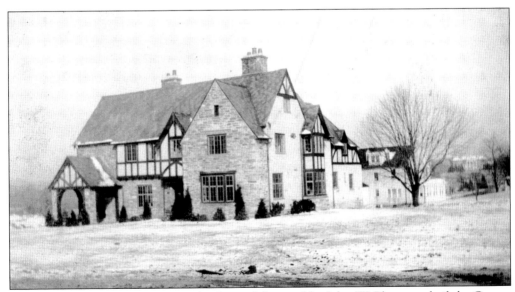

No. 609 Ogden Avenue, a 1929 Tudor Revival designed by John W. Platt, was built by George Gillespie for Dr. W. F. G. Swann. Photographed around 1930, it is an example of the substantial homes built on remaining lots in the tract in the 1920s and 1930s. Swann was director of the Bartol Foundation, the Franklin Institute's physics research facility located on Whittier Place on the Swarthmore College campus from 1927 to 1977.

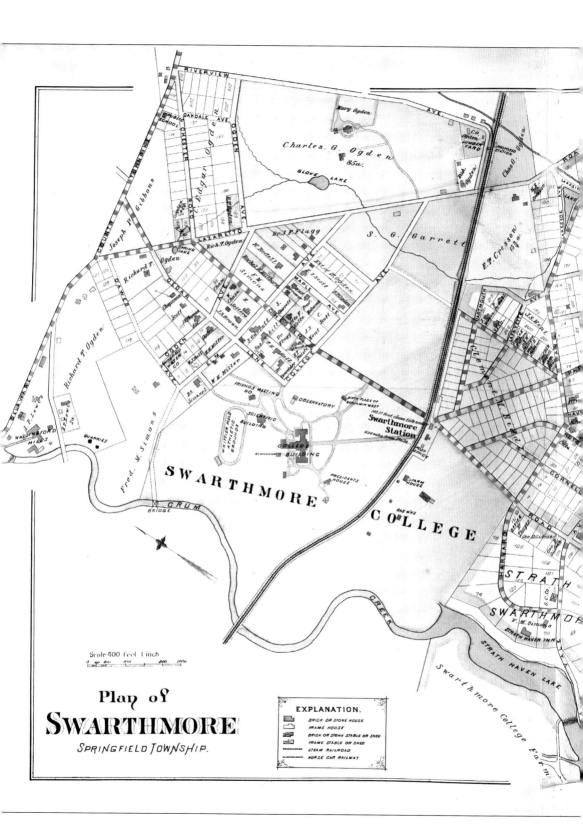

Scale 400 feet 1 inch

Plan of
SWARTHMORE
SPRINGFIELD TOWNSHIP.

EXPLANATION.
BRICK OR STONE HOUSE
FRAME HOUSE
BRICK OR STONE STABLE OR SHED
FRAME STABLE OR SHED
STEAM RAILROAD
HORSE CAR RAILWAY

This is a plan of Swarthmore from the *Smith and Mueller Atlas* of 1892. This map of Swarthmore shortly before its incorporation shows the West Hill, Swarthmore Improvement, Swarthmore Construction, and College Tract plots as well as sizable properties still privately held by Charles Ogden, E. T. Cresson, Joseph Gilpin, and Sylvester Garrett. Development of these tracts continued into the mid-20th century. The last large property to be intensely developed was the Gilpin tract in the 1950s.

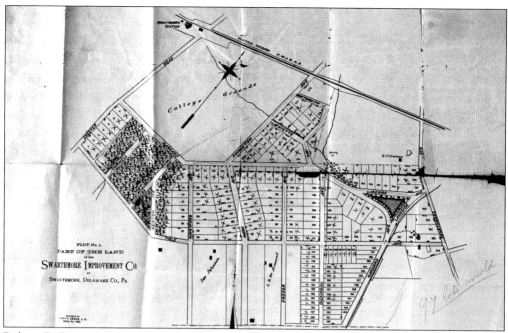

Robert P. Green produced the plot plan, "Part of the Land of the Swarthmore Improvement Company," in 1886. The officers and board of directors of the Swarthmore Improvement Company and Swarthmore Construction Company were essentially the same people, albeit holding different positions.

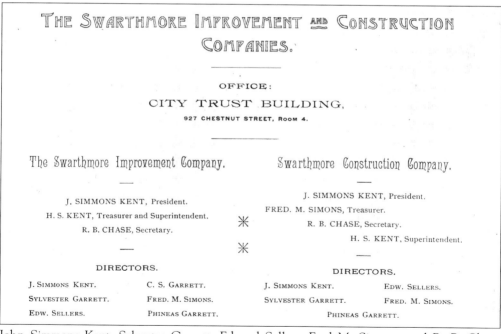

John Simmons Kent, Sylvester Garrett, Edward Sellers, Fred M. Simons, and R. B. Chase built some of the first homes on the West Hill Tract in the early 1880s. Sylvester Garrett's son, Albert N. Garrett, and John Simmons Kent's older brother, Henry S. Kent, also were active in the companies, as indicated in the company brochure, *Illustrated Swarthmore*, around 1890.

Three

SWARTHMORE AND COLLEGE TRACTS

By 1882, a cluster of buildings had been erected on the college campus in addition to scattered buildings on the West Hill Tract north of College Avenue. With the improvement of the rail line in the early 1880s, homes along the Media–West Chester Line (the Central Division) became desirable suburban retreats for people who worked in Philadelphia.

This was the age of the early commuter suburbs that sprang up rapidly along the main line and other divisions. A number of the borough's prominent first citizens came to Swarthmore in the early 1880s, initially buying homes on the Hill. Soon they began to invest and promote real estate in development tracts south of the railroad.

In 1886, two development companies were established, Swarthmore Improvement Company and Swarthmore Construction Company. Swarthmore Improvement Company laid lots in the area between Dartmouth, Rutgers, and Harvard Avenues and into Ridley Township to the south. The adjacent development company was the Swarthmore Construction Company that laid out lots west of Cornell and south of Harvard Avenues.

A booklet, *Illustrated Swarthmore*, was published by the Swarthmore Improvement Company around 1890 to advertise the desirable location and amenities. It touted the beauty of Crum Creek for boating and skating, available livery service from the station, and home delivery of groceries. It noted that macadam roads and electric lines were being installed, and a local school would open soon. By 1892, over 30 homes populated the area.

In 1891, the college decided to divest itself of its property south of the railroad and bounded on the west by Chester Road and the south and east by the Swarthmore Improvement Tract. Clarence Scott, John Cass, and Clement Biddle were active in the development of the College Tract. Earlier, Swarthmore College engineering students were involved in designing Harvard Avenue.

A small but thriving business district developed along Park Avenue, Dartmouth Avenue, and South Chester Road to serve the college and residents as well as two "resort" hotels, the Grange and Strath Haven Inn. The remainder of the College Tract was residential.

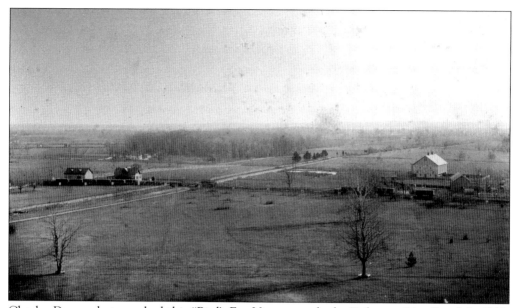

Charles Doron photographed this "Bird's Eye View towards the Delaware River" in July 1880, which was distributed as No. 11, "From Top of College Looking South-East" in his "Swarthmore and Vicinity" series. The train station and college farm are in the center field. The illustration also pictures the small wooded area southwest of Harvard Avenue shown in the Swarthmore Improvement Company plot plan of 1886.

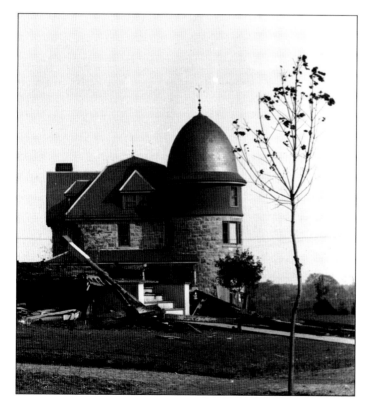

About 1886, John Simmons Kent (died 1896), president of Swarthmore Improvement and Construction Companies, moved from his Italianate home on North Chester Road to this impressive Romanesque Revival house at 123 South Princeton Avenue. An ardent supporter of temperance, Kent erected a water fountain on the lot where Trinity Church now stands and was a friend of John Wanamaker. A flat roof replaced the copper turret after a fire.

Henry Simmons Kent (1833–1906), real estate agent and superintendent for the Swarthmore Construction and Swarthmore Improvement Companies, was active in the antislavery movement and a founder of Swarthmore Monthly Meeting. He and his wife, Patience, are buried at Longwood Progressive Meeting of Friends in Kennett Square, a center of Underground Railroad activities and reform causes.

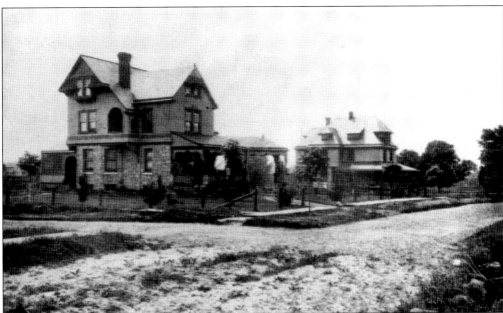

This photograph appeared in the booklet *Illustrated Swarthmore*, published by the Swarthmore Improvement Company around 1890 to advertise its homes. Pictured on the left is 11 South Princeton Avenue. A similar house with a porte cochere was built at 119 South Princeton. No. 19 South Princeton is on the right; a much altered version of this house was built at 410 Harvard Avenue.

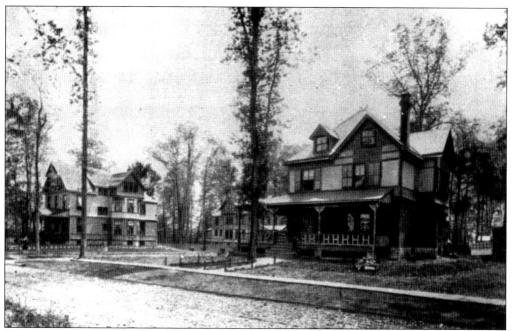

The homes on the corner of Harvard and Rutgers Avenues, 426 and 500, also were featured in *Illustrated Swarthmore*. The Swarthmore Preparative School briefly rented the properties in the early 1890s. No. 426 Harvard Avenue, on the left, was the main building and dormitory. Much enlarged, it is now an apartment building known as the Harvard.

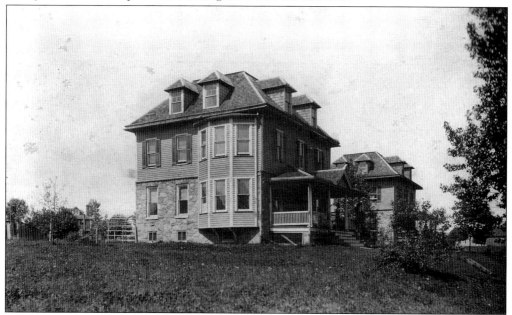

The two classic American foursquare homes at 310 and 314 Lafayette Avenue, around 1900, were designed by Samuel Milligan, who probably was the architect for many of the homes in the Swarthmore Improvement and Construction Tracts. While streets on West Hill were largely named after trees, streets south of the rail line were named after colleges. Dartmouth and Lafayette Avenues were opened in December 1892. (Courtesy Alice Putnam Willets.)

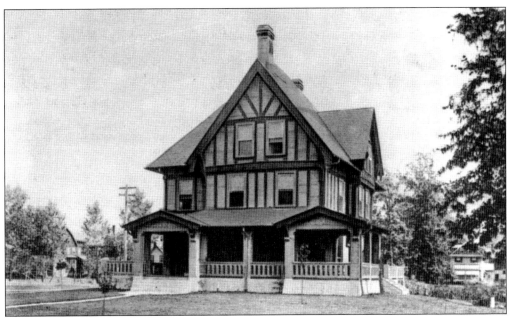

The stuccoed and half-timbered Queen Anne–style house at 201 South Chester Road was designed and owned by Howard B. Green, class of 1892. It is ornamented with beautifully crafted Mercer tiles. Green, who as a student was awarded first prize in 1891 for his plan dividing the College Tract into building lots, worked as a civil engineer and also as a salesman for the Portland Cement Company.

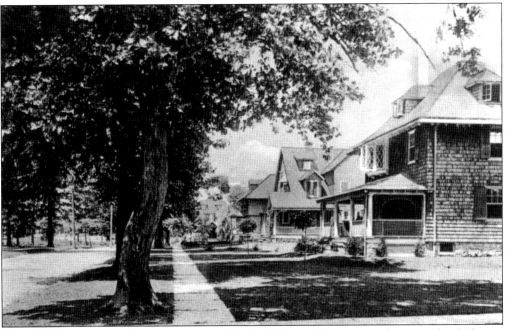

This hand-colored postcard shows the 500 block of Harvard Avenue on the east side of Chester Road. The first house, on the corner of Harvard and Rutgers Avenues, is a 1907 American foursquare with an arts and crafts interior. Carroll Thayer, who also may have drawn the original house plan, designed a later addition containing medical offices. (Courtesy Keith Lockhart.)

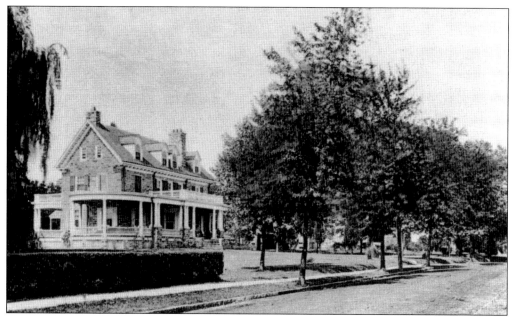

After Arthur H. and Emma P. Tomlinson established a new campus for the Swarthmore Preparative School on South Chester Road in 1896, they built this handsome Colonial Revival–styled headmaster's residence with an elegant wrap porch at 200 South Chester Road. It was constructed in 1907 and designed by Quaker architect Morgan Bunting. (Courtesy Keith Lockhart.)

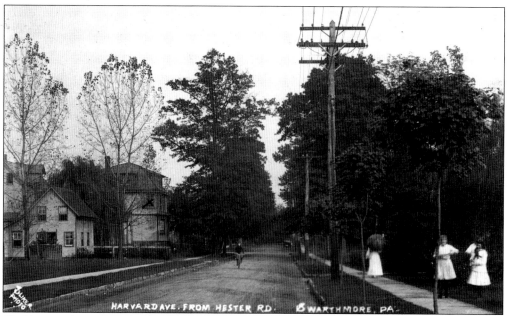

Children and a woman with a parasol walk down the sidewalk on Harvard Avenue, as seen from Chester Road. An anonymous message on the reverse of the postcard notes that the writer's room is marked with an x. The card continues that the house faces Cornell Avenue "which is exceedingly pleasant. Lots of trees—too many around some of the houses." (Courtesy Keith Lockhart.)

This early-1900s snapshot shows a peaceful South Chester Road with the college barn and farm in the background. The tracts south of Yale Avenue were not significantly developed until after 1920.

The author of inspirational Christian romantic novels, which are still in print, Grace Livingston Hill (1865–1947) was one of Swarthmore's most famous citizens during her lifetime. She bought a small Colonial Revival house at 215 North Cornell Avenue early in the 20th century that she enlarged in 1917 with Romanesque Revival and arts and crafts details. Here she is photographed sitting by her fireplace. (Courtesy Swarthmore Presbyterian Church.)

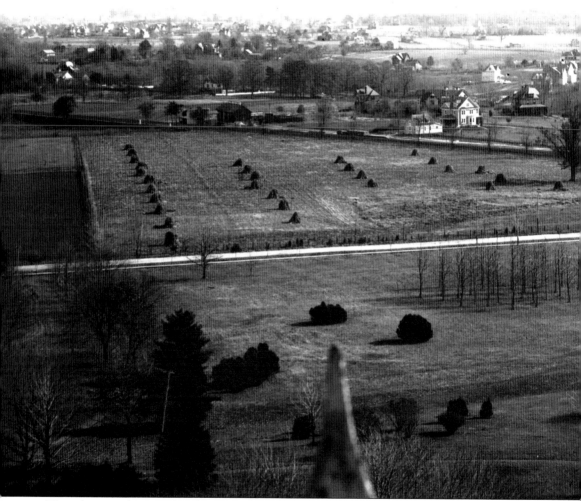

This photograph was taken by Ezra T. Cresson from the top of Parrish Hall on November 12, 1898, looking west toward the college fields on the east side of Chester Road. In the 18 years since Charles Doron's view, almost from the same spot, development south of the railroad tracks is very evident. Note density in the Swarthmore Improvement Tract, with Kent's copper turret in

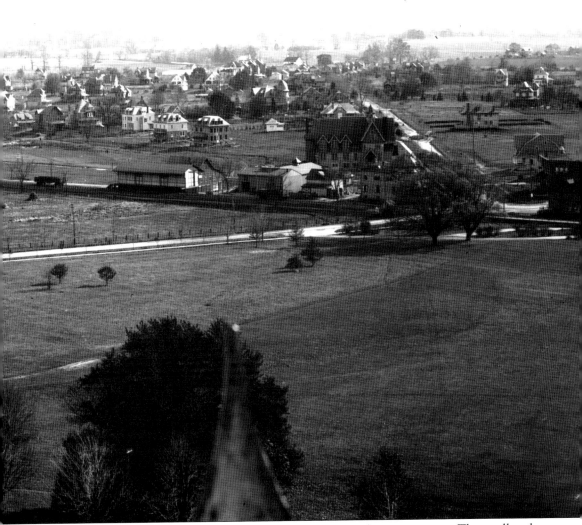

the center. The foursquare houses on Lafayette Avenue are under construction. The small park on Park Avenue and the nucleus of the business district are on the right side of the photograph. Hay has been piled on the college fields north of the tracks. (Courtesy Charles O. Cresson.)

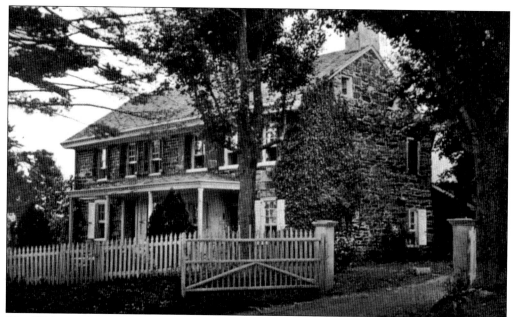

The 1736 stone house at 530 Cedar Lane is Swarthmore's best surviving example of the Colonial era. Listed on the National Register of Historic Places, the property was purchased in 1806 by John Ogden. His son, John Ogden Jr. (1788–1877), expanded the property that Richard T. Ogden inherited at his father's death. This view, "Homestead of John Ogden," was published in Charles Burr Ogden's 1898 book, *The Quaker Ogdens*.

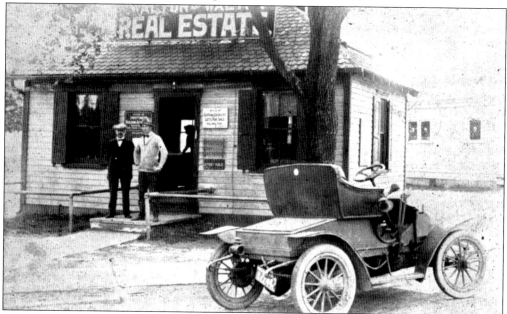

Henry S. Kent, joined in partnership in 1901 by his nephew E. Clayton Walton, established one of the first realty companies. The building in the photograph was originally erected farther south on Chester Road in 1890 by William H. Brannon as a pavilion with all sides open and was moved to this location in 1896. The image also shows Henry Kent's motorcar, one of Swarthmore's earliest "gas buggies."

Four

OTHER REAL ESTATE DEVELOPMENTS

In addition to the large tracts developed by real estate development companies, smaller properties were developed into the late 20th century. The northern part of Swarthmore followed this pattern as additional Ogden land became available.

The property inherited by Richard T. Ogden was north of the West Hill Tract and included a stone house built by John Maddock in 1736. The farmhouse remained in the Ogden family until 1923, when the property was subdivided. Charles G. Ogden inherited 80 acres to the east of the West Hill Tract, where he kept a farm and operated a lumber and coal yard. Louis Cole Emmons developed a large part of this property in the 1920s as Riverview Estates. William Witham built the remainder as Swarthmore Hills. An unmarried sister, Mary T. Ogden, was given a house on Swarthmore Avenue, surrounded by Charles's property. Another brother, Clement, kept a farm which lay north of Ogden Avenue and east of Chester Road. After his death in 1886, this was subdivided by his heir, C. Edgar Ogden.

South of the railroad, Joseph Gilpin held over 69 acres, E. T. Cresson almost 16. Sylvester Garrett, Frederick Simons, and others owned sizable tracts. These were subdivided at the end of the 19th century and beginning of the 20th century, even as early tracts were further splintered.

Carroll Thayer, Swarthmore's most prolific builder, came to the borough in 1906. He designed residences, most in the arts and crafts style, and also constructed custom homes for other developers. Clarke and Harvey (Parrish and Magill Avenues), William Witham (Crest Lane, Swarthmore Hills), George Gillespie (Strath Haven Tract), Charles Fisher (Dickinson and Columbia Avenues), and Robert Bird (southern end of Cornell Avenue) also played prominent roles. Almost 90 percent of Swarthmore's buildings were erected by 1930.

Besides the building of the underpass in 1930, the biggest change in the character of Swarthmore, from a small college village into a suburban community, was the massive task of installing sidewalks and curbs in the late 1930s and early 1940s, particularly near the town center.

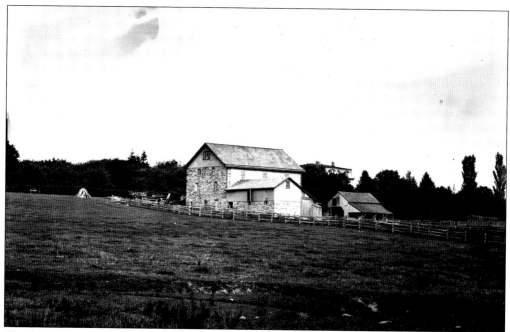

Charles G. Ogden (1831–1900) inherited 85 acres of farmland east of Swarthmore Avenue. The property, which boasted a fine collection of trees and a small lake, was sold to Louis Cole Emmons, who razed the house in 1916 to make way for his Riverview Farm mansion. Ogden was also a bank director and operated a coal and lumber yard on the north side of the railroad.

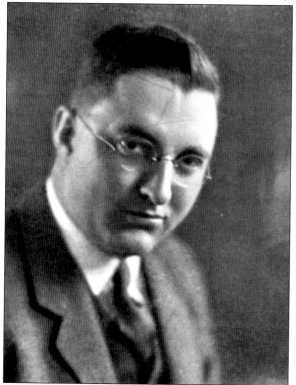

Louis Cole Emmons (1887–1934), president of coal mining and oil companies, developed Riverview Estates in Swarthmore and Lapidea Hills in Nether Providence in the 1920s. He hired prominent architects to design high-quality homes on Ogden, Riverview, and Guernsey Avenues. He often used local contractor Carroll Thayer to construct the houses. This portrait of Emmons was featured in *The History of Delaware County*, published in 1932.

Houses were built in a variety of revival styles, including Pennsylvania Farmhouse, Tudor Revival, and Country French. On his estate, Riverview Farm, Emmons indulged his hobby of raising prize-winning thoroughbred Guernsey cows. A substantial barn housed a federally-accredited herd of 80 purebred cows, memorialized in the name of Guernsey Road. This advertisement appeared in the March 21, 1930, issue of the *Swarthmorean*.

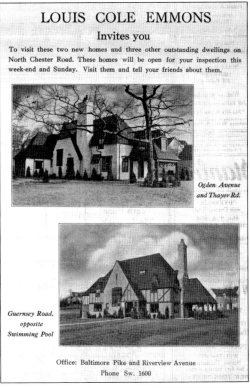

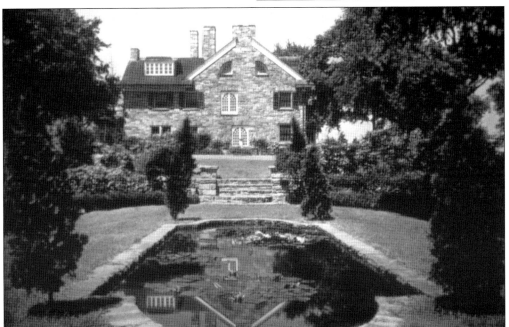

In 1916, Louis Cole Emmons and his wife, Alice Lemon Emmons, built a fine estate house on the site of Charles Ogden's farmhouse with a view of the Delaware River in the far distance and a ballroom on the third floor. This photograph of the mansion was taken from below the reflecting pool on the south side of the house. (Courtesy Charles O. Cresson.)

After 1920, Emmons allowed the public to use the swimming pool on his property, free to families who bought milk from his dairy and $1 a day for noncustomers. This photograph was taken about 1931. In 1953, the cement-lined pool was filled in when a home was constructed at 124 Guernsey Road.

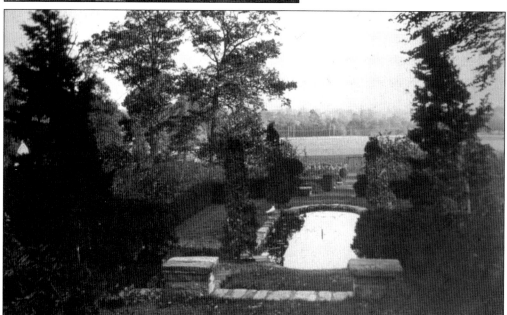

This photograph was taken from above the reflecting pool on the south side of the Emmons mansion, with a view toward the Delaware River. In later years, the Country Week Picnic was held on the extensive grounds. From 1890 to 1941, the picnic involved about 200 mothers and preschool-age children who came to Swarthmore from Philadelphia by train for an afternoon "in the country" each summer. (Courtesy Charles O. Cresson.)

While not a registered architect, Carroll Thayer (1862–1938) designed and built about 150 homes in the borough beginning in 1906. He continued to be active into his 70s; in 1932, after a hiatus in construction due to the Depression, he was the first contractor to obtain a building permit. This house was constructed on Swarthmore Place, developed by Thayer in 1927–1930, to showcase a variety of housing styles.

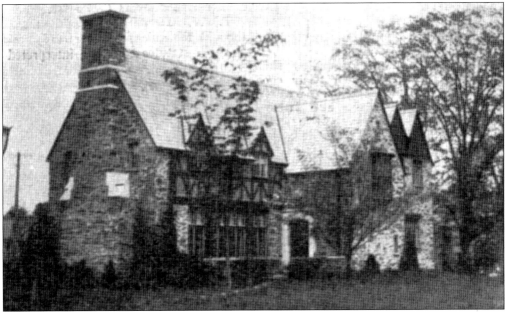

In 1928, William E. Witham (1881–1966) purchased a tract from developers Clarke and Harvey that had been part of the Gibbons Estate. He envisioned Swarthmore Crest as a model residential park. After the sudden death of Louis Cole Emmons, Witham developed homes in Riverview Estates and Swarthmore Hills. He built his own home in the Tudor Revival style on Swarthmore Crest, here shown in the *Swarthmorean* on May 23, 1931.

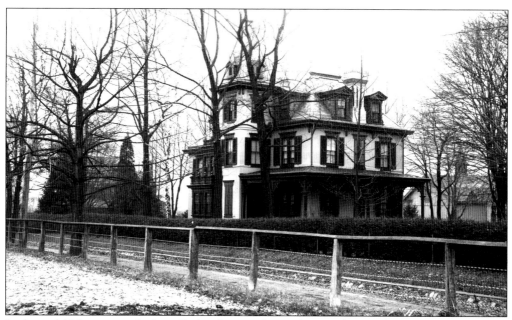

In the mid-19th century, the Linville family owned a gentleman's farm in the southeastern section of Swarthmore. The Italianate mansion, now 12–14 South Swarthmore Avenue, was built prior to 1870, possibly for C. W. Rush. In 1883, Samuel R. Linville sold the 15-acre property to Ezra Townsend Cresson, secretary of the Franklin Insurance Company, who named it Hedgleigh for the Osage orange hedgerows. (Courtesy Charles O. Cresson.)

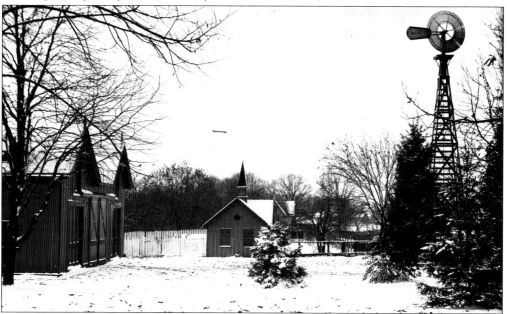

Hedgleigh included a tenant house, barn, springhouse, and windmill. Ezra T. Cresson was a noted amateur entomologist and the son of Warder Cresson. Warder was born into a Philadelphia Quaker family and subsequently explored Shaker, Mormon, and Millerite beliefs. An early Zionist, he converted to Judaism and died in Palestine. Ezra T. Cresson's interests included photography; he took the exterior photographs of Hedgleigh in 1898. (Courtesy Charles O. Cresson.)

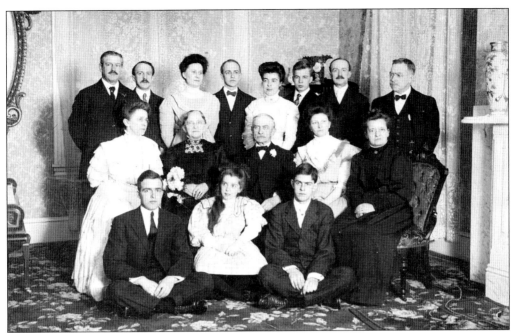

This formal portrait was taken on March 2, 1909, in Hedgleigh's parlor on the occasion of the golden wedding anniversary of Ezra T. and Mary R. Cresson. They are seated in the center, surrounded by their children (George, Emma [married Richard Ogden], Warder, Ezra, and William), spouses, and grandchildren. (Courtesy Charles O. Cresson.)

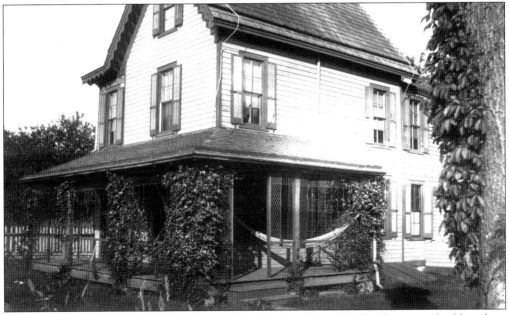

After the death of his wife in 1909, Ezra T. Cresson subdivided the farm into building lots, with his children establishing homes on Amherst Avenue. The 19th-century tenant house was moved to 37 Amherst Avenue. This photograph of the simple vernacular farmhouse was taken at the original location, before it was remodeled in a Colonial Revival style. (Courtesy Charles O. Cresson.)

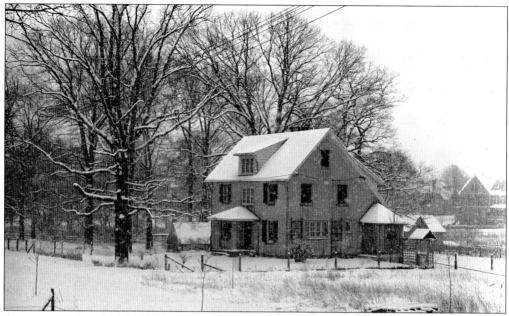

Between 1909 and 1912, Ezra's son William J. Cresson built a home at 32 Amherst Avenue on a lot that included a springhouse and established trees. By 1925, using water from Little Crum Creek, he had laid out a garden with a pond and a series of terraces and garden rooms on less than two acres. This photograph was taken shortly after the house was built. (Courtesy Charles O. Cresson.)

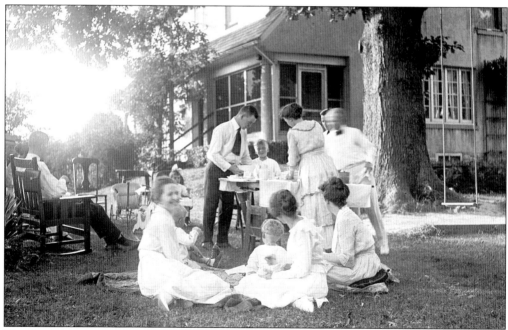

This birthday picnic in the yard took place in July 1919. William J. Cresson is standing at the far right, and his son, William J. Jr., age 10, is behind the table. Through the 1900s and into the 21st century, William J. Jr. and his sons continued to cultivate the garden. Hedgleigh Springs has been featured in many garden tours, articles, and books. (Courtesy Charles O Cresson.)

Frederick M. Simons (1862–1935) was an important early citizen of the borough. President of a Philadelphia silver manufacturing firm, he and his wife, Marion, established their residence on West Hill in 1883. He built the Strath Haven Inn in 1892 and was active in the civic life of the community, serving on the borough council. (Courtesy Swarthmore Presbyterian Church.)

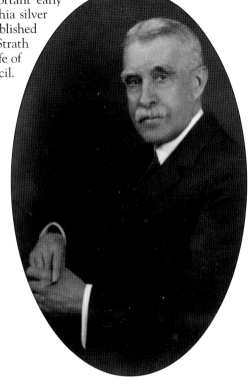

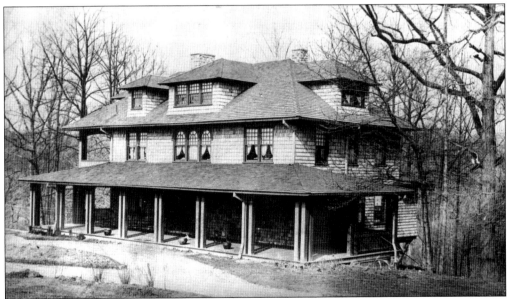

A founder of Swarthmore Presbyterian Church, Simons donated the land for the church building and developed real estate south of the railroad and on Harvard Avenue. The Lodge was built next to the inn in 1900. It served as the Simonses' summer residence until about 1915, when it became their year-round home. The large shingle-style house is built below street level on the hillside above Crum Creek.

Another important builder and developer in the 1920s and 1930s was George Gillespie (1894–1939). A graduate of Princeton University, he developed the Strath Haven Tract on Chester Road, University, Cornell, and Strath Haven Avenues. His "Blue Star" sample home on University Avenue, fully furnished and equipped with the latest appliances, was featured in 1928. Gillespie also built about 100 quality homes throughout the borough for individual home owners. (Courtesy George Gillespie.)

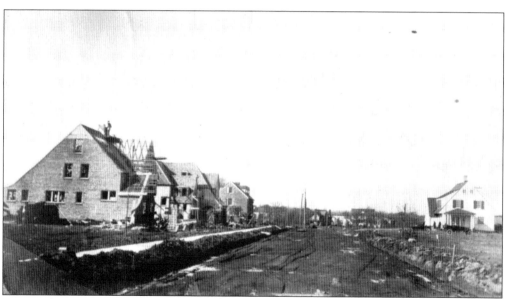

During the Depression, Gillespie advertised his homes at discounted prices and touted the advantages of safe, quiet suburban streets off the main thoroughfares. He noted that the commute via the new Sproul Viaduct to the businesses and industries in Chester was less than 15 minutes. This photograph shows homes under construction in 1929 on Strath Haven Avenue looking west from Cornell Avenue. (Courtesy George Gillespie.)

Around the turn of the 20th century, Joseph Gilpin built twin houses on Kenyon, Yale and Brighton Avenues for the workers at the Grange. This section became the heart of Swarthmore's African American community as families moved up from Maryland around 1890, finding work in the community and then in factories and businesses. Ownership of the homes on Kenyon, Yale, and Brighton Avenues remained in the Gilpin family until 1962, when Joseph Gilpin's daughter, Elizabeth Gilpin Moore, died at the age of 101. The top photograph shows homes on Kenyon Avenue in the late 1930s. The Gilpin tract was the last large undeveloped property in Swarthmore. The aerial photograph was taken around 1931, showing part of Gillespie's Strath Haven Tract in the upper left corner. After a fire destroyed the main Grange building in 1937, the property was cleared for development. (Courtesy George Gillespie.)

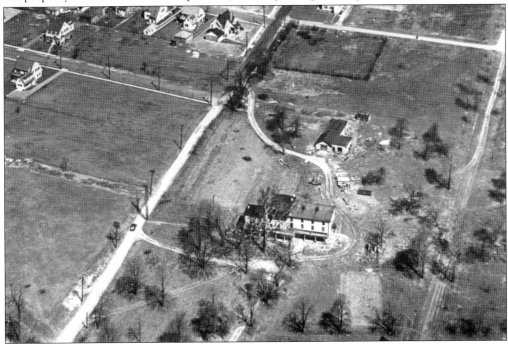

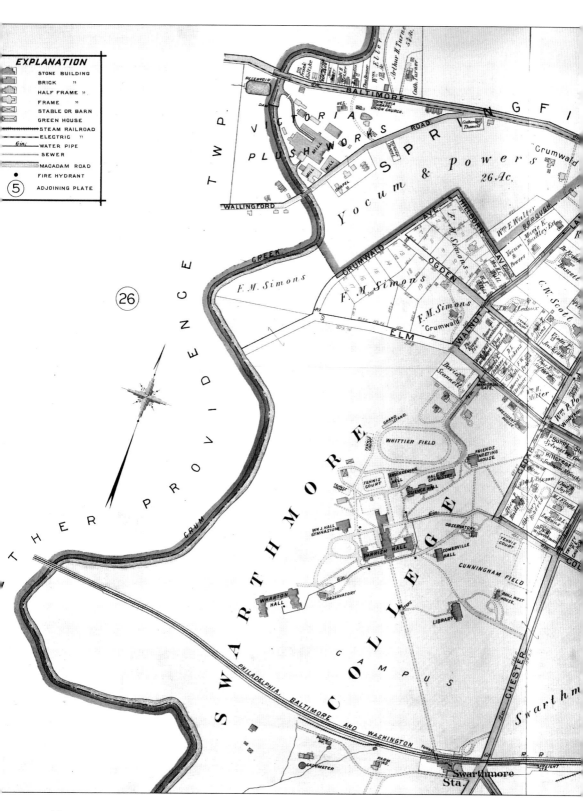

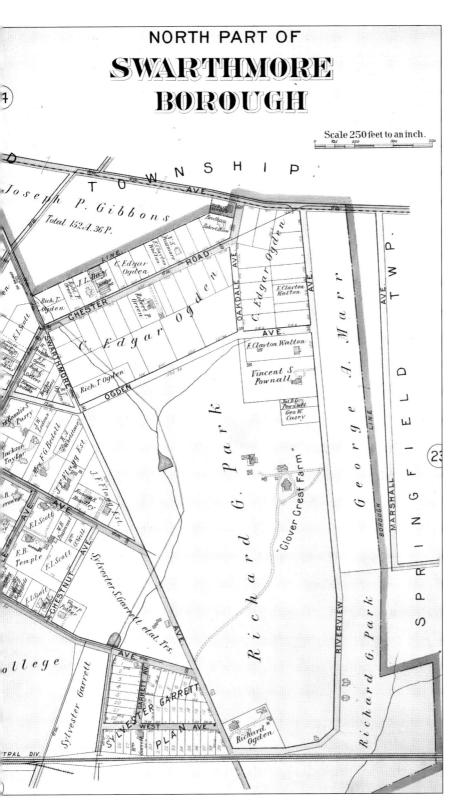

Scale 250 feet to an inch.

A. H. Mueller's *Property Atlas of Delaware County East of Ridley Creek* was published in Philadelphia in 1909–1910.

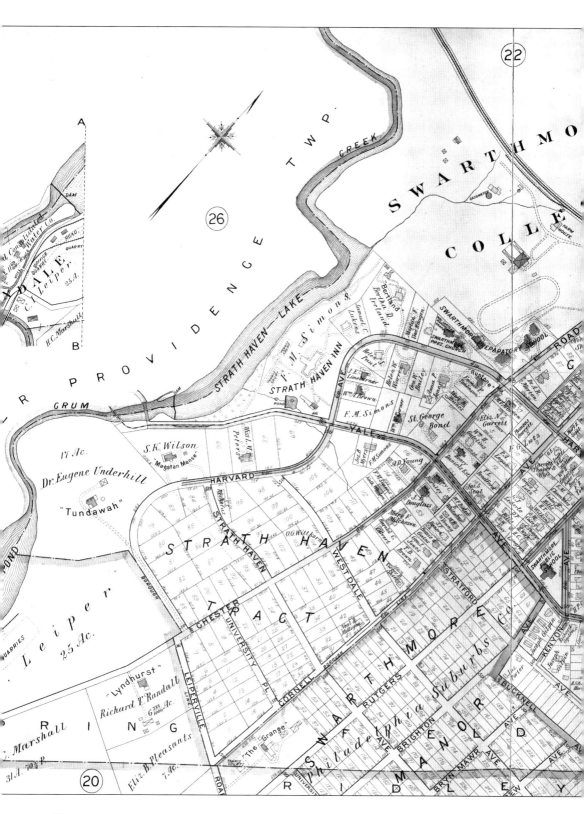

SOUTH PART OF
SWARTHMORE
BOROUGH

Scale 250 feet to an inch.

EXPLANATION

STONE BUILDING	
BRICK "	
HALF FRAME "	
FRAME "	
STABLE OR BARN	
GREEN HOUSE	
STEAM RAILROAD	
ELECTRIC "	
6 in. WATER PIPE	
SEWER	
MACADAM ROAD	
● FIRE HYDRANT	
⑤ ADJOINING PLATE	

Two maps, north and south sections of the borough, show the remarkable development of Swarthmore to that point. Mueller published at least three atlases of Delaware County.

69

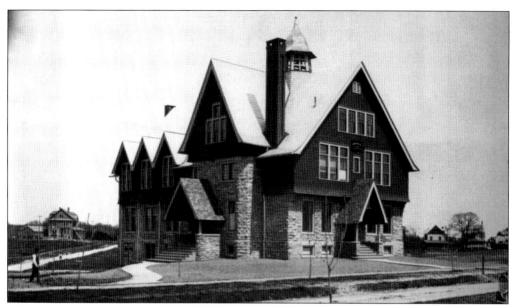

After the borough was incorporated, the Reverend John A. Cass announced plans for a large public building to be constructed by a stock company in the College Tract. The new structure would house a public hall, offices for council, and stores. By October 1893, work was well underway. Swarthmore Hall was an impressive stone and shingle edifice that faced Dartmouth Avenue. It was designed by Amos Boyden and constructed by S. E. Horne. This building served as borough hall from 1908 to 1950. By 1909, the bell tower was finished, and in 1914, borough fire equipment was moved in from a fire hall near Chester Road and Elm Avenue. The photograph on top dates to about 1910. The bottom photograph was taken from the same vantage point about 30 years later, with Russell's Auto Repair on the current site of the Keystone Bank.

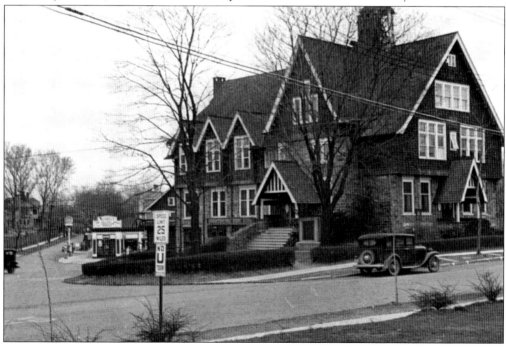

Five

GOVERNMENT AND TRANSPORTATION

Interest in forming a separate municipality from Springfield Township is evidenced as early as 1885. A small group met at the Oakdale schoolhouse on Baltimore Pike and Oakdale Avenue on May 9, 1885, to discuss the idea. Sylvester Garrett chaired this meeting. While some of the landowners of large tracts felt the matter was premature, the editor of the *Media Record* noted that the meeting had been amicable, and a committee was appointed to pursue the discussion. Within a few months, a survey had been conducted for a possible borough between Baltimore Pike and Yale Avenue.

By 1892, convenient transportation via the railroad and the Baltimore Pike had stimulated the growth of three real estate development tracts adjacent to Swarthmore College. An application for a charter was filed with the Court of the Commonwealth of Pennsylvania on December 5, 1892, and on March 6, 1893, the request was approved. The original boundaries were Baltimore Pike on the north, Crum Creek on the west, and Riverview Road and Swarthmore Avenue on the east. The southern border lay approximately on a continuation of Bowdoin Avenue and did not include the section that continues south to Michigan and Fairview Avenues. That area was part of Ridley Township until 1929. A small area from Ridley and Springfield Townships on Swarthmore's southern boundary was annexed on January 30, 1931.

The first meeting of the borough council was held on March 24, 1893, chaired by burgess-elect E. Irvin Scott. Members of the first council were Richard T. Ogden, Frederick M. Simons, Charles Parker, John A. Cass, Sylvester Garrett, and Edward Sellers. The meeting was held in the schoolroom of the union hall on Kenyon and Yale Avenues. Until 1908, the council met at various locations, including Swarthmore Hall.

In 1908, by a close vote in a special election, a bond issue of $25,000 was passed to fund buying a lot and building a borough hall. Instead, the thrifty council decided to purchase Swarthmore Hall for $13,500 and spend an additional $3,000 on repairs.

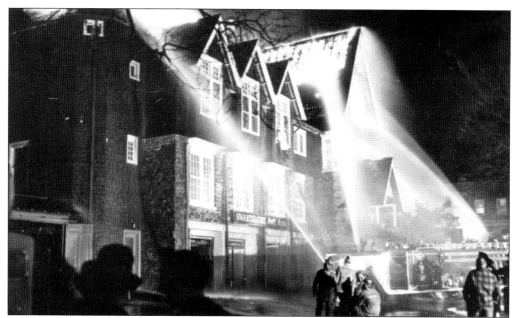

Swarthmore Hall served as the borough's municipal building and also housed the fire and police departments and public library until an overnight fire on March 15, 1950, badly damaged the top story and roof. Borough records were protected from smoke and water damage either in the vault or by tarpaulins. The library suffered the greatest loss and found temporary quarters in the Bell Telephone building on Harvard Avenue.

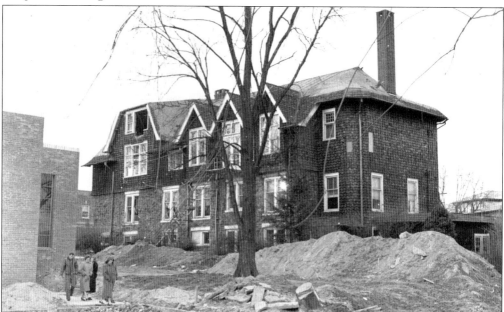

Rather than repair the aging structure, Swarthmore Borough Council decided to build a new facility on an adjacent lot, designed by local architect and former council president, George M. Ewing. This photograph shows the damaged 1893 building alongside a partly constructed brick borough hall that faces Park Avenue. The new building opened in 1952. Swarthmore Hall was torn down to create a parking lot.

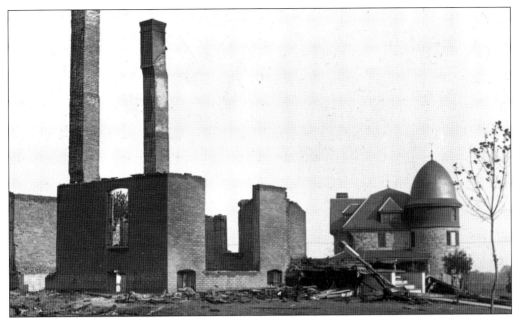

John A. Cass was an important founding father who served on the council, published the first newspaper, and developed real estate, Swarthmore Hall, and the Union Church. He moved to a new house on Park Avenue in October 1893 that was destroyed in a spectacular fire two weeks later. After this conflagration, residents contributed $630 to purchase a fire hose and carriage while the borough provided funding for 11 fireplugs.

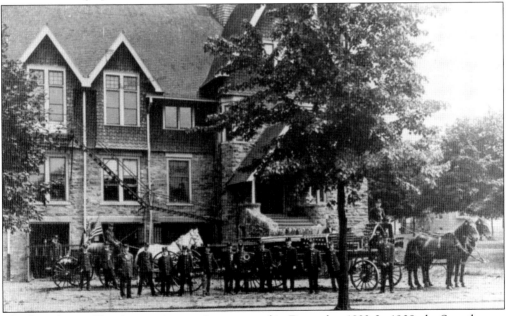

The Swarthmore Fire Association was incorporated in December 1893. In 1908, the Swarthmore Fire and Protective Association was created. By 1911, the association maintained six horses and a two-horse hook-and-ladder truck with a 40-foot extension ladder, smoke apparatus, and extinguishers. The association is pictured in 1909 outside its facilities in Swarthmore Hall. (Courtesy Swarthmore Fire and Protective Association.)

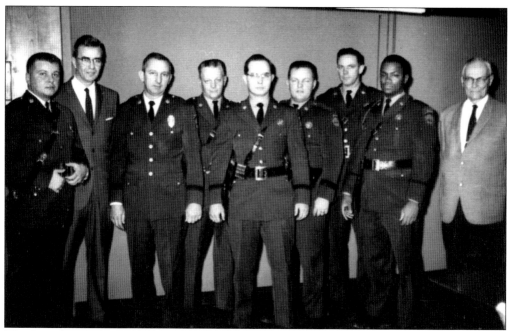

The Swarthmore Fire and Protective Association provided police service until 1912, when the borough hired one paid uniformed policeman. By 1930, the size of the force had grown to include five officers. Pictured is the force in the 1960s. Second from right, Donald Lee was the borough's first African American police officer and was named chief of police in 1991.

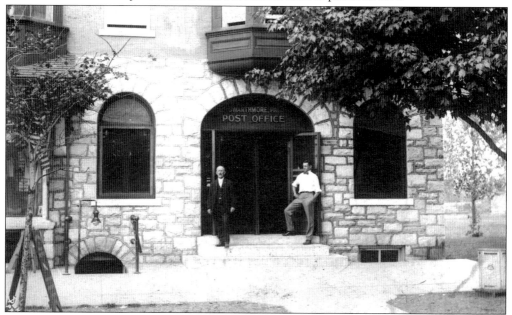

The Swarthmore Post Office was established in 1870 and was first located in a small frame building next to the train station. It moved to several different locations, including the Hannum and Huffnal building on the corner of Park Avenue and Chester Road, at the convenience of the postmaster. Around 1908, it is shown in the new Shirer Building on South Chester Road. (Courtesy Keith Lockhart.)

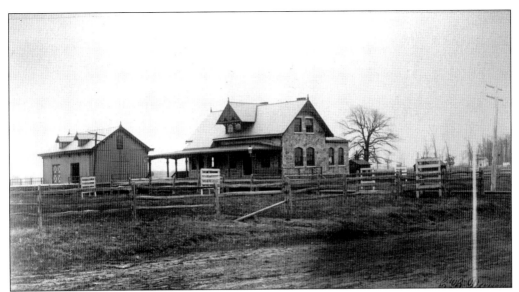

The first train line was built by the West Chester and Philadelphia Company, with service to Media by 1855. The stop, originally known as Westdale, was renamed Swarthmore at the behest of the college in 1870. The present Queen Anne–style train station was built on the south side of the tracks in 1876. This photograph by Charles B. Doron, around 1881, was No. 4 in his "Swarthmore and Vicinity" series.

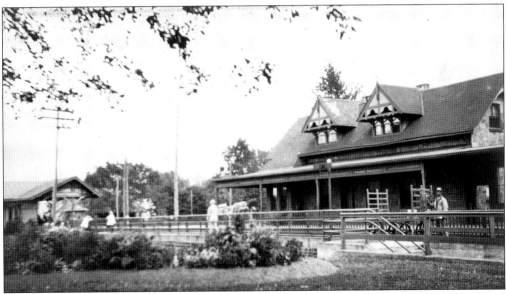

The line was improved in the 1880s from one to two tracks, and the station was enlarged around the dawn of the 20th century. Note the ornamental planting on the north side of the tracks in this early-20th-century photograph. The line later became part of the Pennsylvania Railroad system, and it was electrified in 1928. A partly enclosed covered shed was added in the mid-20th century.

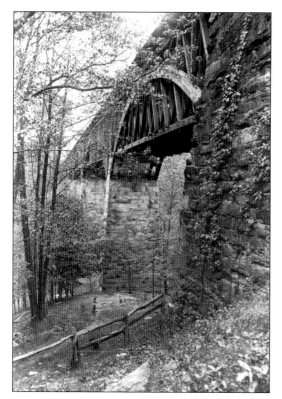

The train line is unusual in its number of high trestle crossings over a relatively short distance. This includes the trestle over Crum Creek and Valley, always a tempting shortcut between Swarthmore and Nether Providence. The earliest recorded tragedy was local resident Serena Worrell, who died from a fall in 1869 on her way to Media. The first trestle was constructed of wood. A watchman by the name of O'Brien made a daily inspection of the bolts and fastenings and followed each train with a bucket of water to extinguish any spark from the engine. The close up photograph (at left) clearly shows the stone foundation and wooden structure. The wooden trestle was replaced by a steel structure mounted on the original stone pillars, as seen in the picture below. Later the pillars were also replaced by steel.

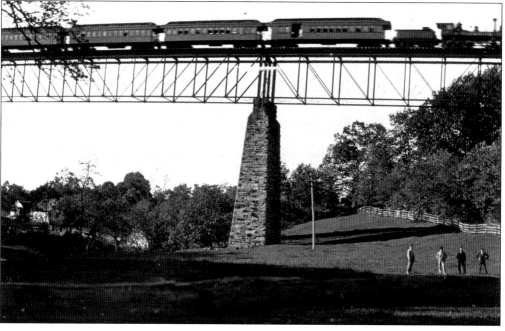

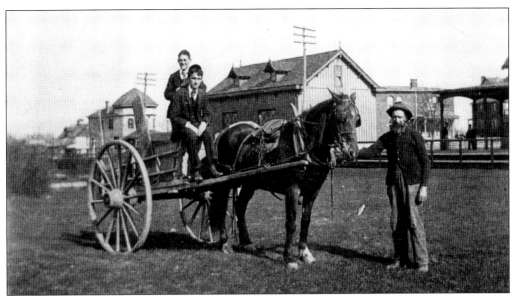

In the early years, Swarthmore College provided transportation for students' trunks from the station to Parrish Hall. Pictured is Old Bill (the horse) with William, the groundskeeper, and two unidentified students around 1892. When Old Bill was not busy hauling personal belongings, he was hooked up to a horse-drawn mower. Smith's general store and Hannum and Huffnal's grocery are in the background, with a large freight building at center.

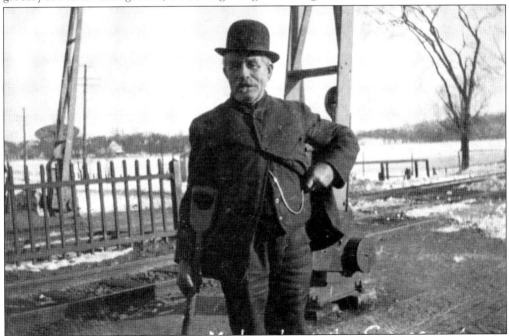

Previous to the completion of the underpass, gatekeepers directed traffic at the dangerous crossing on Chester Road, until they were replaced by automatic gates. The best known was Michael McCarty, seen here, who tended the crossing from 1898 to 1919. According to journalist Drew Pearson, who grew up in Swarthmore, McCarty kept Pres. Woodrow Wilson's car waiting at the crossing and got a presidential commendation for vigilantly doing his duty.

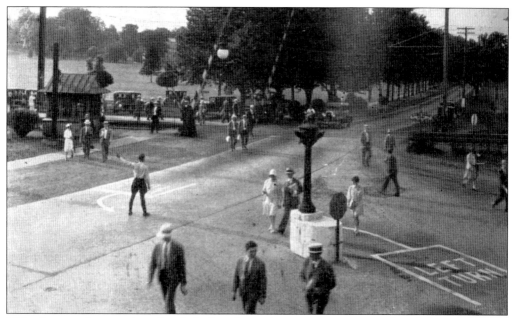

This photograph was taken shortly before the underpass was constructed and shows the lively intersection before traffic was diverted from the business district. A Swarthmore policeman directs foot and auto traffic after passengers are discharged. Before the opening of "the Blue Route" (I-476) in 1991, Route 320, named Chester Road in Swarthmore, was one of the most traveled north–south roads in Delaware County.

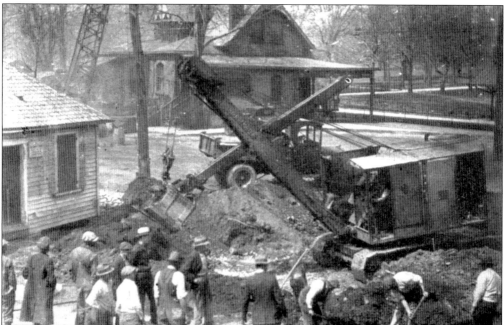

Construction of the underpass commenced in April 1931. The small frame building behind the work area was the Walton Real Estate building, erected in the 1890s and moved to Rutgers Avenue. On November 14, 1931, the Chester Road underpass was dedicated, complete with speakers and a parade of cars.

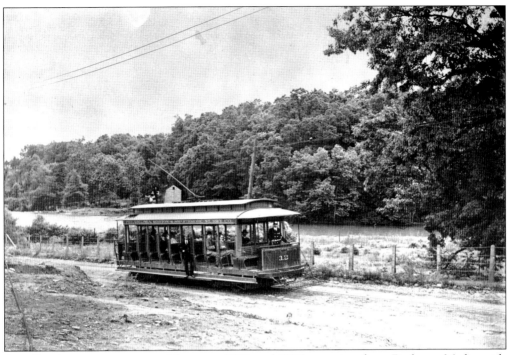

A trolley line was constructed between 1899 and 1904, running from Darby to Media with stops in Morton and Swarthmore. This photograph was taken around 1905 along Yale Avenue near Crum Creek. A branch of a Native American path, the Great Minquas Trail, connecting the Schuylkill and Susquehanna Rivers, ran from Darby, through Morton, and beyond to Rose Valley. (Courtesy Keith Lockhart.)

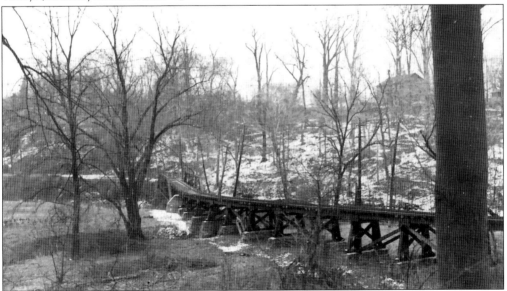

This photograph of the wooden trolley bridge over the Crum was taken about 1920, from Nether Providence looking toward Swarthmore. Only a low railing was on the creek section of the trestle. The Philadelphia, Morton, and Swarthmore Street Railway Company trolley was discontinued in the 1930s. (Courtesy Keith Lockhart.)

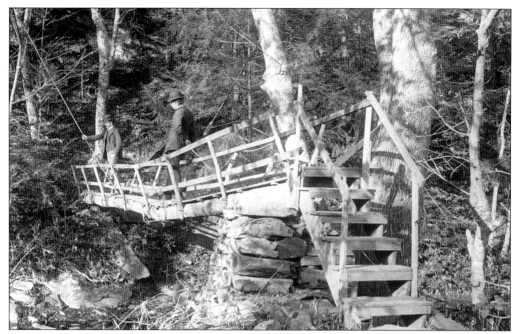

Less formal bridges also crossed Crum Creek, including this footbridge, probably photographed around 1895. The Crum, which supplies drinking water to most of Delaware County, was impounded in 1931 to create Springton Lake. It begins in Malvern and runs 24 miles into the Delaware River at Eddystone.

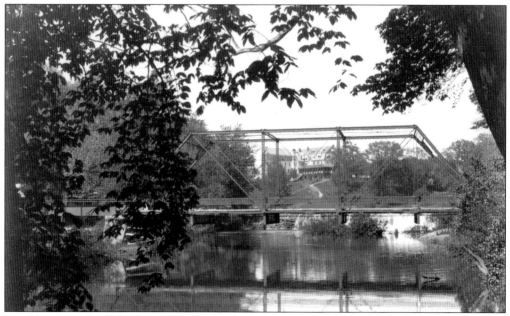

In addition to the Yale Avenue trolley bridge, an iron structure carried other traffic over the Crum, connecting Swarthmore and Nether Providence. This postcard dated 1899 shows the Strath Haven Falls and Inn in the background. This bridge was replaced in the early 1930s by a concrete and stone bridge. After years of controversy about its location, the present Yale Avenue Bridge opened in 1977.

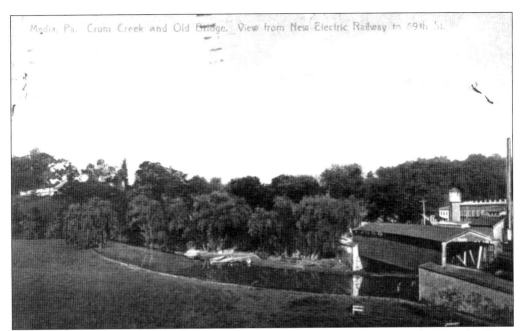

Media, Pa. Crum Creek and Old Bridge. View from New Electric Railway to 69th St.

A covered bridge just north of Swarthmore's boundary carried Baltimore Pike over the Crum until the Plush Mill Memorial Bridge was constructed in 1923. Into the early 20th century, a number of mills were located along Crum Creek. This postcard view of the Lewis Mill (later Plush Mills) was taken from Swarthmore. (Courtesy Keith Lockhart.)

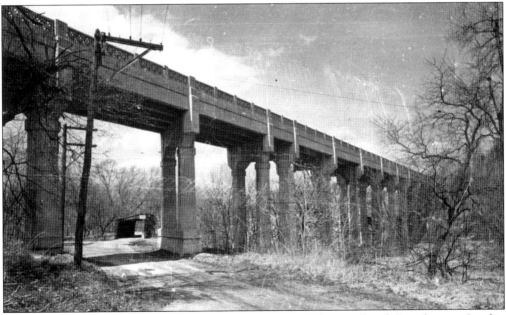

The last surviving covered bridge in Delaware County lay south of Swarthmore. In this photograph, taken about 1925, it stands in the shadow of its successor, the Sproul Viaduct, constructed in 1924. William Cameron Sproul, an 1881 graduate of Swarthmore College, was nicknamed the "Father of Good Roads" in Pennsylvania when he served as governor, 1919–1923. He also expanded the public education system and established Arbor Day.

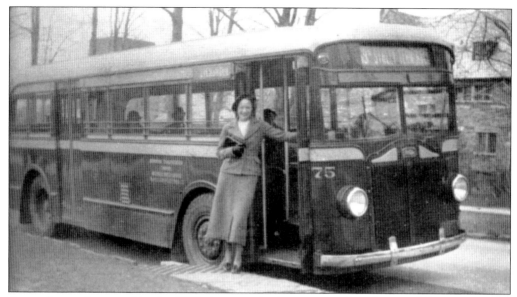

As roads were improved in the 1930s, buses and private cars replaced most of the area's trolley lines. The Red Arrow Line or Philadelphia Suburban Transportation System became part of SEPTA (Southeastern Pennsylvania Transportation Authority) in 1970. Buses still run from the 69th Street Terminal to Chester via Baltimore Pike and Chester Road. This photograph shows a coed in 1936 catching the Aronomink bus on Chester Road for a shopping tour in Upper Darby.

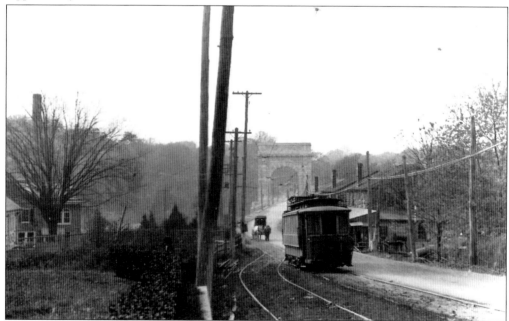

This view, looking west toward Media, shows the Baltimore Pike trolley and the 1922–1924 reinforced concrete bridge over Crum Creek. The bridge had a 70-foot memorial arch marking the entrance to Nether Providence. In the mid-1950s, the widening of Baltimore Pike made the old bridge obsolete. The arch's memorial tablets to the World War I dead were moved to the entrance of nearby Smedley Park. (Courtesy Keith Lockhart.)

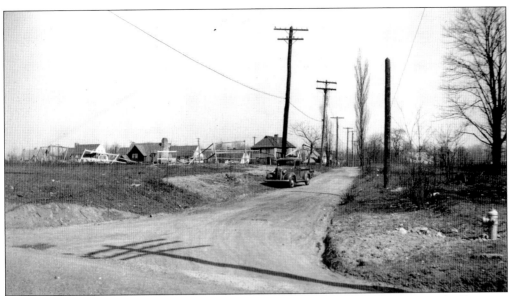

In the 1930s and 1940s, the landscape of Swarthmore was transformed from a semirural village into a suburban college town with the installation of paved roads and curbs throughout the borough and sidewalks in most neighborhoods, especially around the business district. Photographs from a scrapbook, "Before and After," document the changes. Pictured is Cornell Avenue, looking north from Fairview in March 1938, and the same intersection in March 1940.

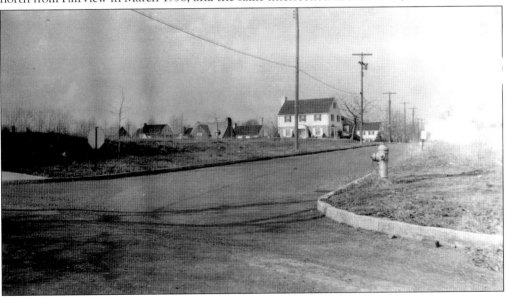

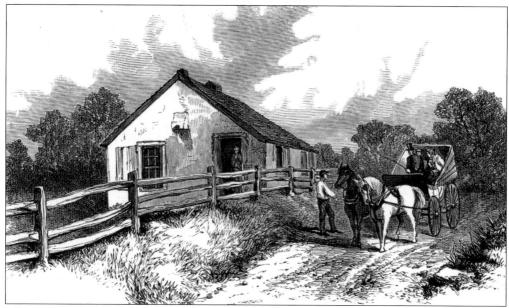

John P. Crozer (1793–1866), 19th-century businessman and philanthropist, grew up in the West House and attended a local one-room school; this engraving was published in *Life of John P. Crozer* in 1868. In 1856, the Springfield School District opened the new Oakdale School on Baltimore Pike and Chester Road. Only the name Oakdale Avenue and a commercially zoned lot on the south side of Baltimore Pike remain.

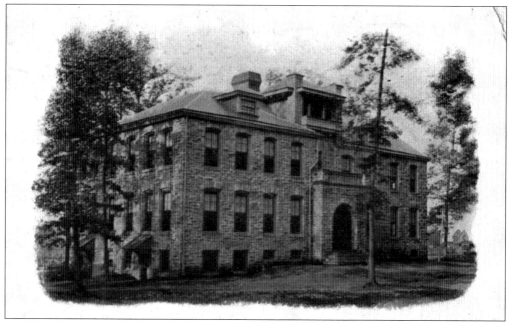

In 1891, the Springfield School District erected a public school on Yale Avenue. It housed students on the first floor and the Union Church on the second. The following year, the school required the use of the entire building, and the Union Church moved to Park Avenue. This photograph, from the early 20th century, is of the second, larger building erected on the same lot in 1898.

Six

SCHOOLS

The first public school available to children in the Swarthmore area of Springfield Township was located on the southwest corner of Yale and Swarthmore Avenues on land donated by William Pennock. Future Chester financier John P. Crozer attended that school, which operated from 1793 to 1856. The building was torn down in 1880. After 1856, local students attended school at Baltimore Pike and North Chester Road in the Oakdale section. In the 1880s, the school-age population south of the railroad grew rapidly, and in 1891, a petition was made to the Springfield Township School Committee for an additional school. The committee purchased a triangular plot of land bounded by Yale, Rutgers, and Kenyon Avenues for the construction of a building with a second story financed by the newly established Union Church.

When the borough was incorporated in 1893, Charles G. Ogden served as the first Swarthmore School Board president. Sixty-five students attended classes in grades one through nine. The district graduated its first class of four students in June 1899. From the inception, many members of the college faculty and staff participated in the borough's educational system, and individuals from the college community have continued to play a strong role in the schools and community.

Swarthmore also had a long tradition of private schools. In 1892, Arthur Hibbs Tomlinson opened a coeducational preparatory school in rented homes, known as the Swarthmore Grammar School and, soon, as Swarthmore Preparatory School. The prep school became a boys-only school in 1913. That same year, Mr. and Mrs. Haldy Miller Crist opened the Mary Lyon School, a school for girls on Harvard Avenue. The Crists also established Wildcliff Junior College. Swarthmore Preparative School closed in 1931, and a school for boys, Ulverston School, operated briefly.

The great majority of Swarthmore students have attended the public schools. Swarthmore District merged with Rutledge in 1955. In 1971, the district was consolidated with Nether Providence to form the Wallingford-Swarthmore School District. The merger was completed in 1983 with the opening of Strath Haven High School.

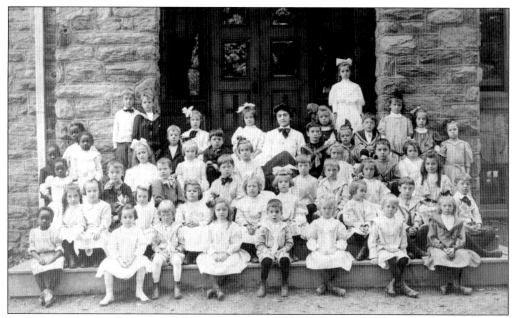

In the Yale Avenue School, one room was set aside for students of color, grades first through eighth, under the direction of an African American teacher. After the Rutgers Avenue School was built, black students in grades one through four attended segregated classes in a "Union Room" until 1939, after which date the school was integrated for all grades. Pictured are students of the Yale Avenue School in 1906 or 1907.

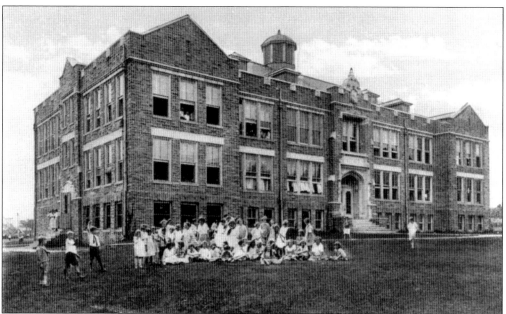

In 1909, the board determined to build a high school. A tract of land was purchased on College Avenue, and the building opened in 1911. The old school became an elementary school, known as the Yale Avenue School. The new building, the College Avenue School, has served all ages of students in the 20th century. This photograph shows the school around 1920. (Courtesy Keith Lockhart.)

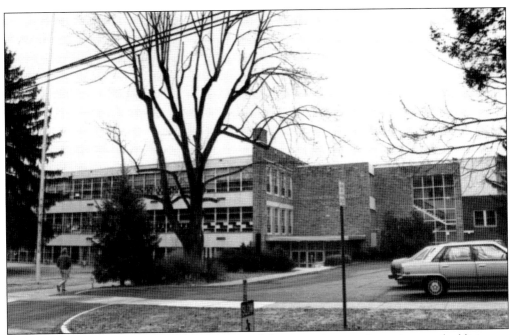

The College Avenue School has seen many modifications, class configurations, and additions, a pattern that continues. After a fire in 1958, it was renovated, and all elementary classes moved to the Rutgers Avenue School. The new facade, shown here, gave the building a mid-20th-century appearance; it was recently again altered in a major renovation. It became the Swarthmore-Rutledge K-8 in 1981, and then the Swarthmore-Rutledge Elementary School in 1991.

With an expanding school-age population in the late 1920s, the school district purchased a nine-acre tract on Rutgers Avenue, intending to construct an additional elementary school designed by the Philadelphia firm of Ritter and Shay. The Yale Avenue School was destroyed by fire in 1929, and elementary classes commenced in the new school in late 1930. Rutgers Avenue School is pictured here around 1939, surrounded by empty lots.

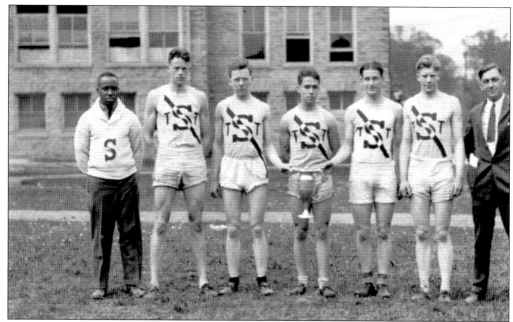

Without a large gymnasium, men's sports teams at Swarthmore High School developed slowly. Track had a long tradition that included three state championships and six wins in the Penn Relays. In 1948, former team member Jeff Kirk ran the 440 hurdles in the Olympics. The photograph shows the high school track team in the 1920s, pictured with their trophy.

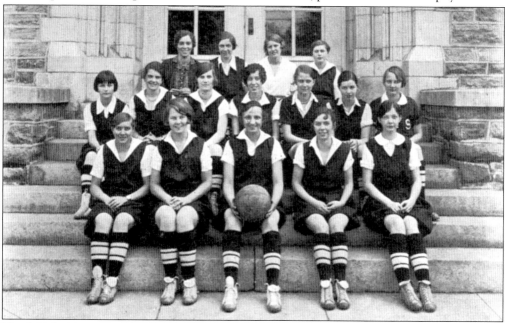

Until Title Nine was approved in 1972, interscholastic sports were limited for girls. This photograph is of the girls' basketball team of 1927–1928 with their coach, Virginia Allen. Allen, a member of the National Lacrosse Hall of Fame and one of the most respected names in women's athletics, came to Swarthmore High School in 1923 and was director of girls' physical education for 34 years.

Before Pennsylvania mandated the consolidation of small school districts, Swarthmore and most neighboring municipalities supported their own school systems. Neighboring high schools developed passionate interscholastic sports rivalries. One of the longest-running contests was the annual Thanksgiving Day football game between Swarthmore and Lansdowne High Schools (later Swarthmore-Rutledge versus Lansdowne-Aldan). When held at Swarthmore, the game was played at the college's field.

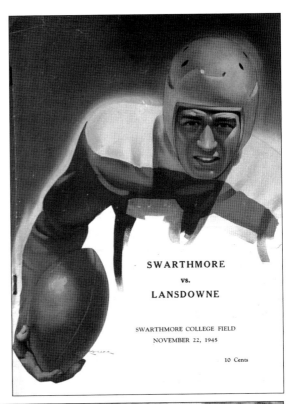

SWARTHMORE

vs.

LANSDOWNE

SWARTHMORE COLLEGE FIELD
NOVEMBER 22, 1945

10 Cents

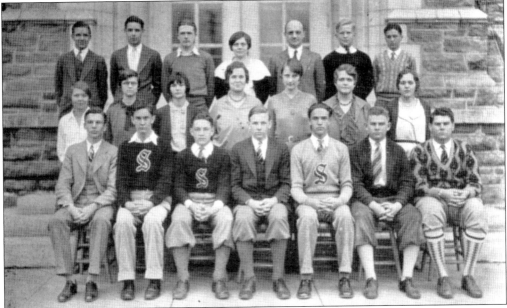

Swarthmore High School was the first school in the vicinity to have a student association. The 1930 cabinet, for example, succeeded in extending the closing time for high school dances to 11:00 p.m. They also worked to improve the school paper *Rara Avis*. This photograph was taken on the steps of the College Avenue building and includes the president, David "Bingle" Bishop, as well as faculty sponsor, Charles A. Brinton.

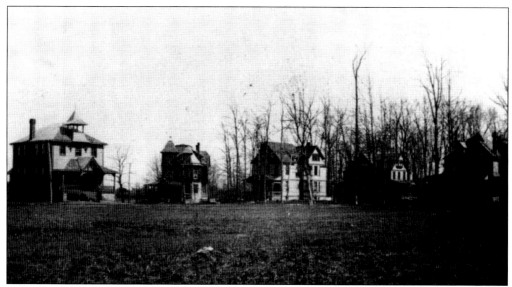

Swarthmore Preparatory School opened in 1892 as a coed day and boarding school. In 1893, it was housed within 426 Harvard Avenue, second from right in the top photograph, but it quickly expanded into two adjacent buildings. No. 209 Rutgers Avenue became the boys' dormitory, and 422 Harvard Avenue was the headmaster's residence. The following year, Recitation Hall was constructed on the opposite side of Harvard Avenue; it is shown on the far left of the photograph with a bell tower and was the only part of the first campus built specifically for the school. The prep quickly outgrew the rented facilities, and in 1896, Arthur Tomlinson moved it to the corner of South Chester Road and Harvard Avenue. The bottom photograph, looking south on Chester Road, was taken of the new campus around 1900. The building in the left corner was a girls' dormitory, later demolished.

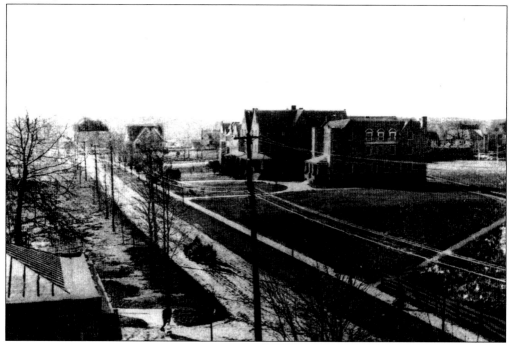

This postcard is dated around 1910. Three of the buildings survive today as college dormitories. After the death of Tomlinson in 1920, his son became headmaster. Incorporated in 1921, the school closed in 1931 because of financial difficulties. Dr. E. L. Terman opened Ulverston School later that year. He moved into the former prep buildings in 1933, but his school closed in 1935. The college acquired the buildings soon after.

Viewed here from Palmer Field, the preparative school gymnasium was built in 1903, designed by Bunting and Shrigley in a shingle style with Tudor Revival features. Soon after, an addition on the west end containing a swimming pool was erected. This section is now the home of the Swarthmore Community Center. The field was named in honor of Prof. Samuel C. Palmer, longtime supporter of Swarthmore College and Preparative School athletics.

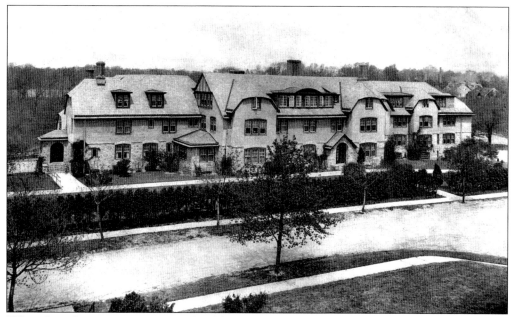

When Swarthmore Preparatory School became boys-only in 1913, Haldy Miller and Frances Leavitt Crist, teachers at the school, opened the Mary Lyon School on Harvard Avenue, named in honor of the founder of Mount Holyoke College. Initially, classes were held in the Strath Haven Inn. Soon three large homes were purchased, and the campus eventually expanded to five buildings. The Tudor Revival complex, built 1917–1918, is now Mary Lyon Dormitory.

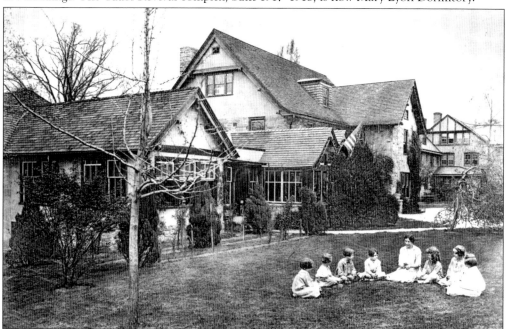

This c. 1920 photograph shows young students with their teacher on the lawn outside "Seven Gables," the junior school for girls under the age of 14. Mary Lyon School accommodated both day and boarding students. The cottage is one of three Mary Lyon buildings destroyed by fire between 1970 and 1982.

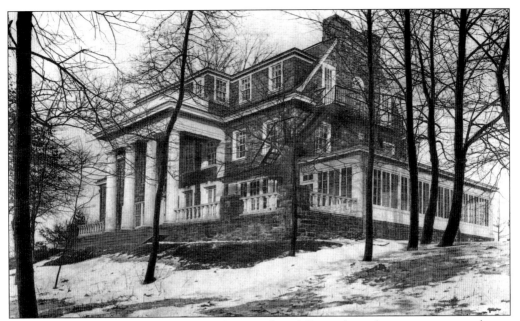

Around 1918, the Crists purchased a large Colonial Revival residence to accommodate a junior college that they named Wildcliff. Magstan Manse was designed by Francis Caldwell for S. K. Wilson in 1909. It overlooks Yale Avenue and Crum Creek and is now used as a faculty residence. Amenities at Mary Lyon included a private golf course, riding trails, and a boathouse on Crum Creek.

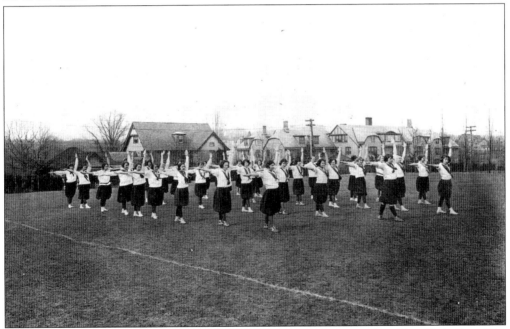

In 1942, Haldy Crist retired, and the Mary Lyon School was moved to New York City. The buildings were leased to the U.S. Navy to serve as a convalescent home during World War II. In 1948, Swarthmore College purchased the campus. This photograph is of students in physical education class on the Harvard Avenue field with Mary Lyon School in the background.

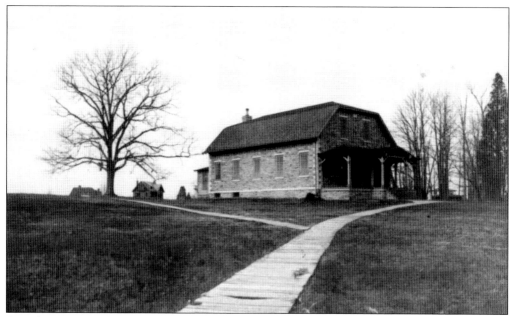

Swarthmore Friends' meetinghouse was built in 1879 with funds provided by financier Joseph Wharton. An atypical meetinghouse style, it was designed by engineering professor Arthur Beardsley. In the first decades of the college, students were required to attend daily worship. Swarthmore Meeting became an independent monthly meeting in 1893. The meetinghouse was enlarged in 1901. In 1911, Wharton financed a larger addition, Whittier House, designed by renowned Rose Valley architect William Lightfoot Price. William and his brother, Walter F. Price, designed or renovated a number of homes in the borough. The top photograph with a boardwalk was taken around 1890. In the photograph below, a crowd observes the 1904 dedication of the new chemistry building (now Pearson Hall) with the meetinghouse and its 1901 addition in the background.

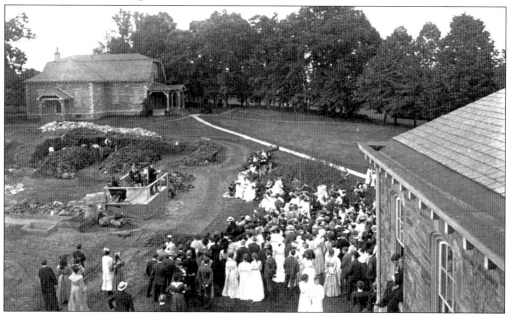

Seven

RELIGIOUS INSTITUTIONS AND COMMUNITY ORGANIZATIONS

A wide variety of organizations have enriched the life of the borough since its beginning. From the Poets Circle, a small group that met in the homes of its members to share an appreciation of poetry, to A.B.C. (A Better Chance Strath Haven), a program designed to give minority teens an opportunity to attend an academically rigorous high school, residents meet their own needs and those of others in the company of like-minded neighbors.

The first denomination to build a place of worship was the Society of Friends, which constructed a meetinghouse on the college campus in 1879. Led by John A. Cass, a Methodist minister, members of several Protestant denominations chartered a Union Church in 1892. Denominations subsequently established their own churches in Swarthmore as their membership increased. Baptist, Lutheran, Roman Catholic, and Jewish congregations built places of worship just outside of the boundaries of the borough.

Swarthmore's social and philanthropic community groups include the Swarthmore Community Center, Garden Club, Centennial Foundation, and Historical Society. A Boy Scout troop was organized in 1911 as an outgrowth of a group of boys who had been meeting at the home of Prof. Jesse H. Holmes.

One of the earliest organized groups was the Woman's Suffrage League of Swarthmore, founded in 1890 as a part of Delaware County Woman's Suffrage Association. Its name was changed to the League of Women Voters after suffrage was granted.

An active organization through most of the 20th century, the Woman's Club of Swarthmore was established in 1898 and nurtured a number of still-vibrant organizations, including the Players Club, Girl Scouts, and public library. Today the Swarthmore Public Library, for example, has the highest per capita usage in Delaware County.

In addition to a myriad of more informal organizations such as book clubs and eating and athletic groups, many events at Swarthmore College are open to the public. The Friends of the Scott Arboretum offers a wide range of horticultural programs and activities. Crum Creek and Crum Woods have long been favorite recreational areas.

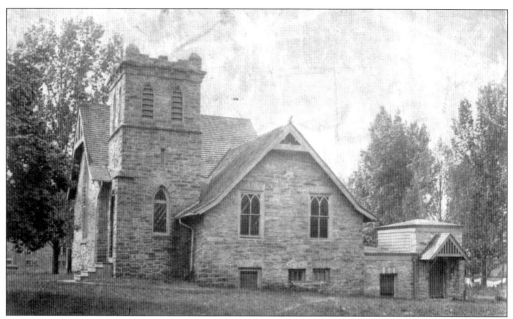

When the Yale Avenue School was built in 1891, the Union Church contributed funds to add a second floor. Within a year, the school required the entire building, and the congregation erected a small stone church on Park Avenue, photographed here from the southwest. In 1901, this property was transferred to the United Methodist Church, the first denominational group to have 50 members within the Union Church.

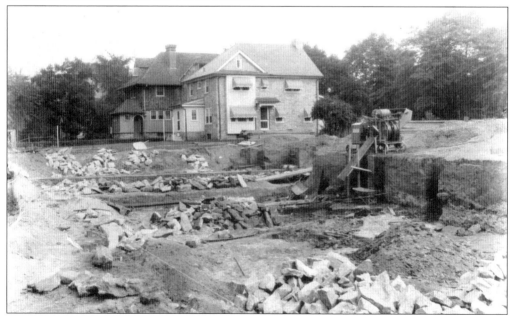

As the congregation of the United Methodist Church flourished, a larger sanctuary and classrooms were required. Ground was broken to the east in 1925. In the photograph, the parsonage on Park Avenue is at the far side of the excavation site. The original Union Church was incorporated into the new building as a chapel; it is the part of the complex closest to Park Avenue. (Courtesy Swarthmore Methodist Church.)

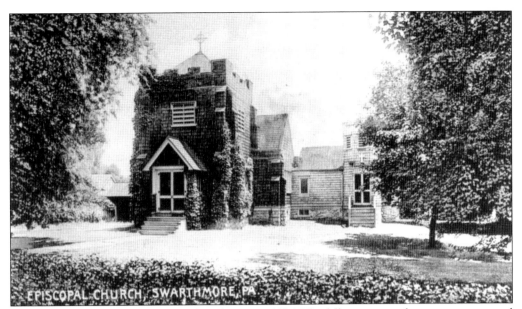

Episcopalians began to meet in members' homes in 1894. The following year, the group constructed a wood-shingled church, Trinity Protestant Episcopal Mission of Swarthmore, on the corner of College Avenue and Chester Road. It was dedicated to the memory of Phillips Brooks, prominent bishop of Massachusetts. Some members dubbed it "the smallest church in the United States, a memorial to the biggest bishop in the Episcopal Church." (Courtesy Keith Lockhart.)

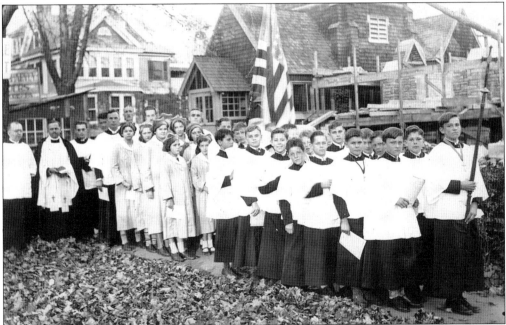

On November 7, 1931, a procession celebrated the laying of the cornerstone for a new Trinity Episcopal Church on the adjacent lot. Member George W. Casey, an architect with Furnas, Evans and Company, who moved to Swarthmore in 1905, designed the English Gothic–styled building. The original frame church, used as a parish house, was demolished in 1951 as part of a building expansion project. (Courtesy Alice Putnam Willets.)

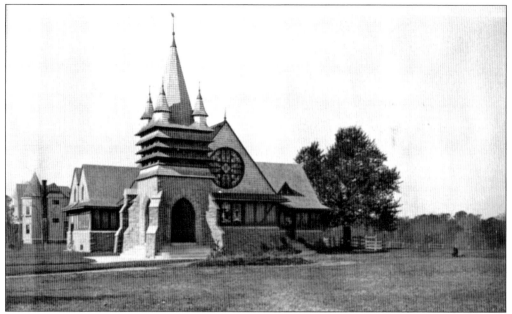

The first services of the Swarthmore Presbyterian Church were held in the Strath Haven Inn in 1895. Frederick Simons, who owned the Strath Haven, donated funds and land on Harvard Avenue. The building was erected in 1896, designed by William Lightfoot Price in the style of a Brittany chapel. This early photograph includes a glimpse of the parsonage that was demolished to make room for later expansion. (Courtesy Keith Lockhart.)

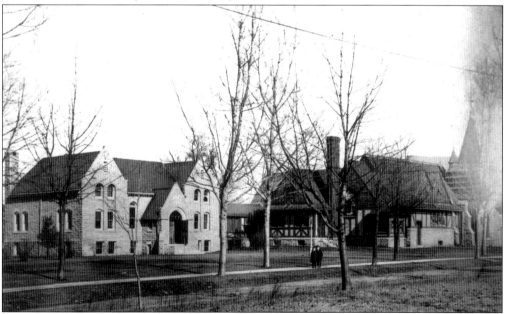

In 1903, the Gibbons family, who owned the estate where the Springfield Mall now stands, contributed funds for a Sunday school addition in memory of their adopted niece, May Loeffler. Visible in this photograph of Harvard Avenue, the Loeffler Chapel is now hidden from the streetscape behind the 1984 Fellowship Hall and a courtyard. The distinctive tower was removed when the sanctuary was enlarged in 1922. (Courtesy Swarthmore Presbyterian Church.)

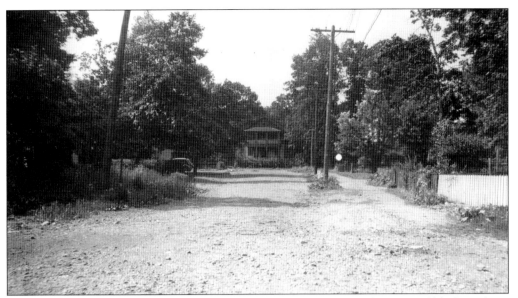

Prior to World War I, there was no African American church in Swarthmore, and black residents attended services in nearby communities. Most were members of Shorter African Methodist Episcopal Church in Morton. Wesley African Methodist Episcopal Church was organized in 1921. Early services were held in Jones Hall on Bowdoin Avenue, now a private home, seen at the end of Kenyon Avenue in this c. 1937 photograph.

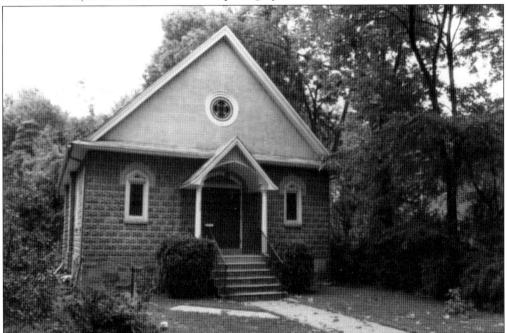

In 1922, the congregation became a member of the Philadelphia Annual Conference. The Reverends R. N. Bundick and Samuel Wilson of Shorter African Methodist Episcopal Church served as the first ministers until the Reverend Alexander White was assigned in 1926. A lot was purchased on Bowdoin Avenue, and the cornerstone for the Wesley African Methodist Episcopal Church was laid in 1927. Carroll Thayer was the builder and served as treasurer.

Christian Scientists in Swarthmore began meeting in a private home in 1918, and a year later, the First Church of Christ, Scientist, was organized. In January 1930, services began at 306 Park Avenue in a church designed by William Pope Barney, noted architect and a member of the denomination. In 1998, the Colonial Revival–style building was sold and converted into a residence.

One community-sponsored holiday tradition is the biennial Pageant of the Nativity, first staged in 1938. This photograph is of an early pageant that was staged at the college. The production is in a modified "tableau vivant" style where anonymous community volunteers play the parts of Old and New Testament figures.

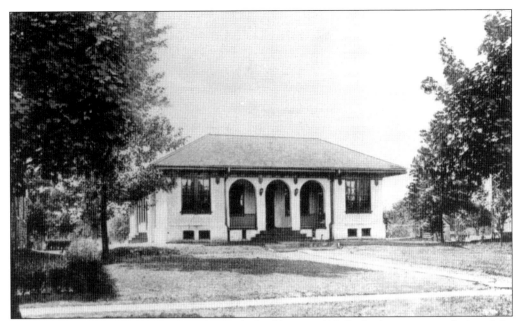

Swarthmore Woman's Club, a mission-style building at 118 Park Avenue, was designed by William Cyril Stanton and erected in 1908. The club was organized in 1898 and federated in 1900. A central community meeting place, it offered a wide variety of programs such as lectures, study groups, teen dance classes, and musicals. The club sold the building in 1991, but continued to support philanthropic efforts.

In the early years, the Swarthmore Woman's Club was divided into sections: mother's, homemaker's, literature, art and music, and garden. Two popular annual events at the clubhouse were the antiques show and the women's exchange. The garden section sponsored an annual fall flower show, open to all gardeners, pictured here in September 1930. Agnes Zimmer was the chairman of the section at the time. (Courtesy Menke and Menke.)

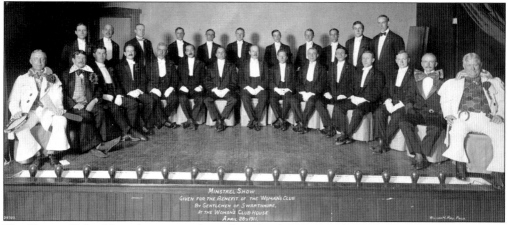

The Players Club of Swarthmore was formed in 1911 by a group of townsmen who came together to produce a minstrel show for the benefit of the Swarthmore Woman's Club. It held its first regular program in 1912. In 1931, a site on Westdale Avenue was proposed for a permanent building, but strict zoning regulations forced the club to look elsewhere. In 1932, the new facility was opened on Fairview Avenue.

The Swarthmore Chautauqua (1911–1930), youngest of the circuit chautauqua, was founded by Paul M. Pearson, Swarthmore professor of public speaking. The group traveled to rural towns on the East Coast for weeks at a time, 1,000 towns in 15 states, where they set up tents to provide education and culture to the American public through lectures, plays, and entertainment. Among notable speakers were William Jennings Bryan and William Howard Taft.

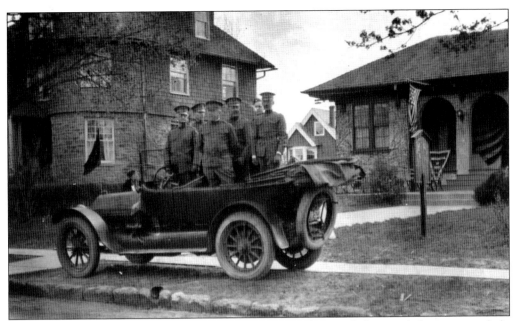

Company H, Swarthmore's Home Guard, was organized in 1917. It provided emergency help during the 1918 influenza epidemic and was reorganized during World War II to serve as part of the reserve militia for the Commonwealth of Pennsylvania. In this photograph, Company H is shown in front of the Swarthmore Woman's Club as members participate in a parade in the Swarthmore business district around 1919.

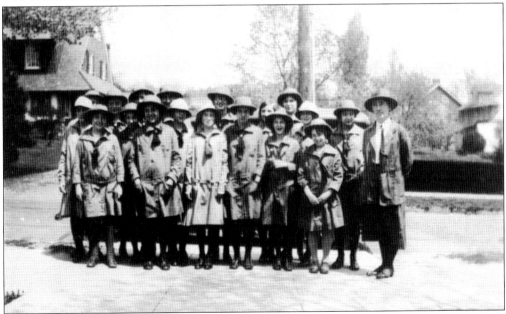

The first Girl Scout troop, Swarthmore Troop 16, was founded in 1922. In 1928, the girls and their leader, Agnes Zimmer, far right, traveled to Washington, D.C., and met Pres. Herbert Hoover. When work on the underpass was completed in 1931, the Girl Scouts moved a construction shed to Little Crum Creek on Cresson Lane, just north of Swarthmore Avenue, for use as a meeting place. Zimmer led Troop 16 until 1942.

The tradition of Santa's Christmas Eve visits to Swarthmore's children dates back to about 1887 when Frederick M. Simons brought a costume home from Germany. This Christmas photograph was taken in 1899 of the Price children in the home of their grandparents, J. Foster and Mary Craft Flagg, at 205 Elm Avenue. The Prices were married at the Flaggs' home, Quarry Edge, and lived next door. (Courtesy Mary Jane Small.)

A Memorial Day tradition was the parade from Swarthmore Borough Hall to Eastlawn Cemetery at the south end of Park Avenue in Ridley Township. Five subscribers from Swarthmore incorporated Eastlawn in 1894: John A. Cass, William Hall, Frederick Simons, Irwin Scott, and Clarence Scott. The cemetery is the resting place for many of Swarthmore's citizens. Pictured is Boy Scout Richard Keppler, placing a flag on the memorial tablet in 1937.

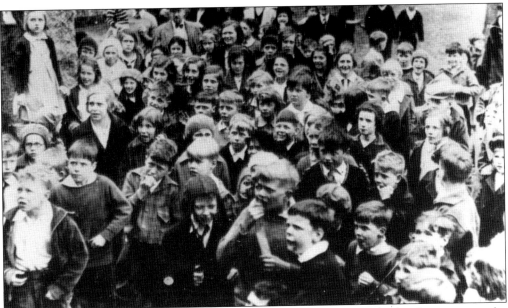

The first Easter egg hunt was held in 1931 and was sponsored by the local newspaper, the *Swarthmorean*. This 1931 photograph shows the children somewhat impatiently waiting on the steps of Swarthmore Borough Hall for the announcement of the location of the hunt on the Swarthmore College campus. A holiday tree lighting and small-town Independence Day parade are other important Swarthmore traditions.

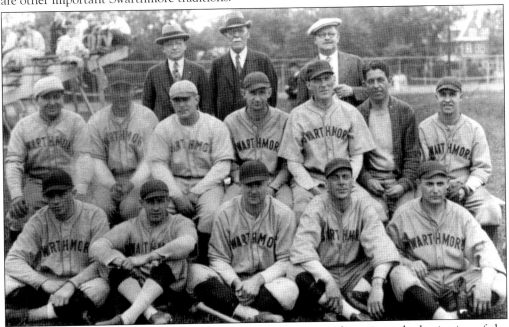

Swarthmoreans have been involved in adult amateur sports at least since the beginning of the 20th century. The Swarthmore Collegians, for example, were a baseball team that played from 1923 to 1933. Pictured are members of the 1929 team, including E. C. Walton, Leonard Ashton, Rudy Yarnall, and Jack Rupp. Local entrepreneurs backed many of the clubs, and often games were played on the college grounds.

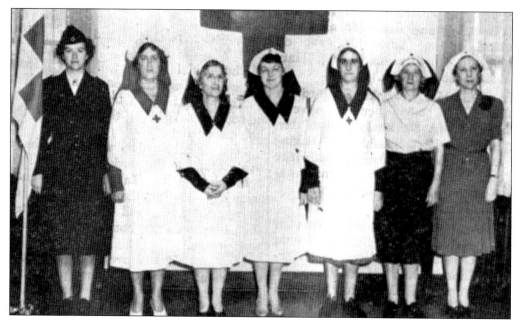

The Swarthmore Branch of the Red Cross was established in 1917. During World War II, the group provided surgical dressings, hospital garments, canteens, and nursing and home services. Pictured are the branch officers in 1941, including (from left to right) Elizabeth Bassett, wearing her motor corps uniform; Mrs. Sewell W. Hodge, Mrs. Addison S. Wickham, Mrs. W. Burton Richards, Mrs. W. W. Turner, Mrs. Wayne H. Randall, and Mrs. Franklin S. Gillespie.

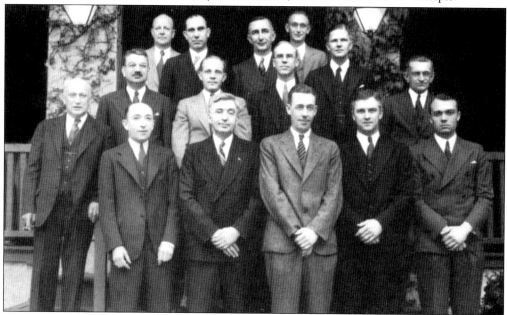

The Swarthmore Rotary Club was organized on April 1, 1937. With its motto "Service Above Self," this organization of business persons in Swarthmore is dedicated to educational and charitable pursuits. Until 2000, the club met monthly in the Ingleneuk Tea House on Park Avenue. Founding members of the Swarthmore Rotary Club are shown on the steps of the Swarthmore Woman's Club.

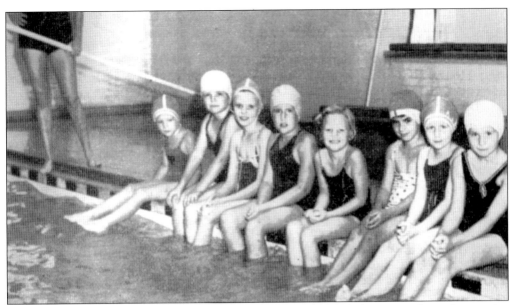

The Swarthmore Recreation Association was chartered in 1940 to provide and supervise recreational programs in the borough. In the early years, it offered arts and crafts, sewing, canoeing and horseback riding, swimming, and other sports. During World War II, its board worked with the Swarthmore Borough Council to start victory gardening. Pictured are the members of the beginners' swimming class at the Swarthmore College pool during the summer of 1940.

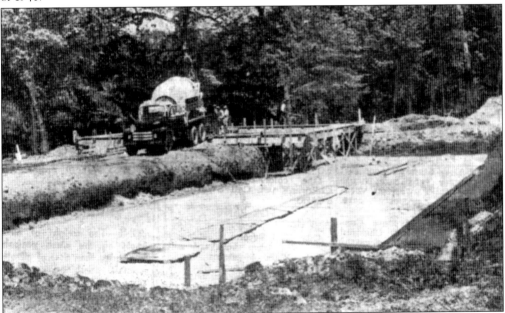

The Swarthmore Swim Club, shown here under construction, was opened in 1955 at the southeast end of Riverview Road. In 1949, entrepreneurs had attempted to build a swim club just south of Fairview Avenue on South Chester Road, but this project never got off the ground. A private club, the Swarthmore Swim Club initially was limited to 400 families who were residents of Swarthmore.

Keystone Automobile Club Park Memorial to Joseph H. Weeks was designed by Clarence Wilson Brazer in 1930 for the triangular plot bounded by Chester Road, Oakdale Avenue, and Baltimore Pike. The club, now AAA Mid-Atlantic, began in 1900, and many local citizens were founding members. Joseph Weeks of Rutledge was president, 1907–1919. This sketch shows the original ambitious plan, later much modified.

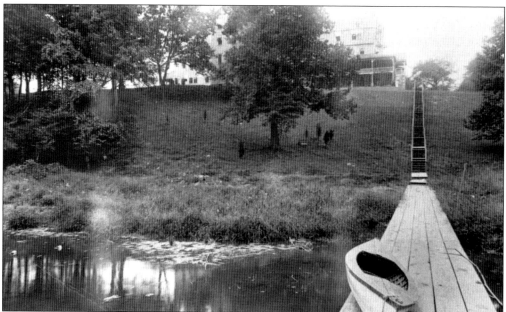

Crum Creek, named from the Dutch meaning "crooked creek," provided a scenic recreational area. A shallow lake below the Strath Haven Inn provided an opportunity for a range of outdoor activities, as evident in this c. 1898 photograph. A boathouse was built in the late 19th century, and canoes were available to rent. In 1931, Crum Creek was impounded to create Springton Lake, reducing the water flow.

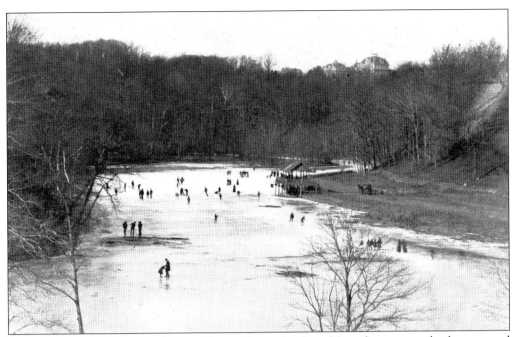

The history of Yale Avenue dam on the southwest border of Swarthmore goes back to around 1776, when it is thought Dr. Robert Harris established a mill to produce gunpowder. This photograph of skaters on the Crum Creek was taken around 1900. After the mid-20th century, it became unusual for conditions to allow skating.

At the establishment of the Scott Foundation in 1929, director John Wister recommended that a priority should be made of creating a naturalistic garden in the Crum Woods on the western border of the campus. Shown here, the woods were cleared of debris and paths laid as a joint college-borough unemployment relief project in 1931 and 1932. The arboretum encompasses the 300 acres of the Swarthmore College campus.

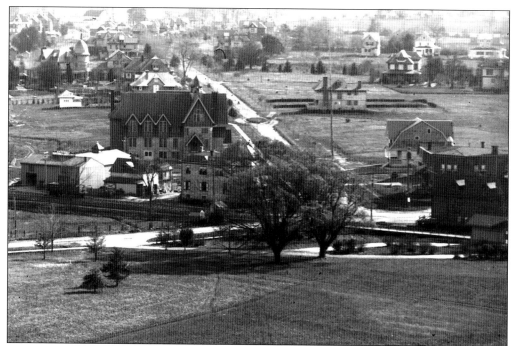

The dome of Parrish Hall was an obvious magnet for amateur photographers. Ezra T. Cresson took this photograph looking down Park Avenue on November 12, 1898, when only Swarthmore Borough Hall and a few businesses near the Park Avenue and Chester Road intersection were established. The building second from right in the middle ground, next to Hannum and Huffnal's grocery, was a residence built for Henry and Annie Daniels. The house still stands behind the storefront of Paulson Rug Company at 100 Park Avenue. Note the development of the Swarthmore Improvement Tract in the background. The detail of the 1909 A. H. Mueller map shows the expansion of the business district only 10 years later. (Above, courtesy Charles O. Cresson.)

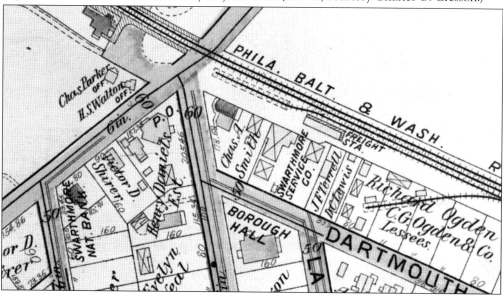

Eight

BUSINESSES

The business district, or the Ville as it is nicknamed, began to take shape only after residential areas were established. In 1891, the college decided to divest itself of the land south of the railroad and bounded by Chester Road and the Swarthmore Improvement Tract. Clarence Scott, John A. Cass, and Clement Biddle were active in the development of the College Tract.

In July 1891, the *Morton Chronicle* reported that since the wheat was now ready to harvest on the college farm, the section of Park Avenue to the station would be opened soon. Park Avenue between Chester Road and Harvard Avenue was erroneously called College Avenue on some early maps of the tract.

In May 1891, it was announced that Howard B. Green, class of 1891, had been awarded first prize for the best plan for dividing the tract into building lots. Earlier, Swarthmore College engineering students were involved in designing Harvard Avenue. Dartmouth and Lafayette Avenues were opened in December 1892.

A small but thriving business district quickly developed along Park Avenue, Dartmouth Avenue, and South Chester Road to serve not only the residents of the borough and college but also two resort hotels, the Grange and Strath Haven Inn. Swarthmore Woman's Club clubhouse was erected on Park Avenue in 1906, and in 1918, the Ingleneuk Tea House moved to 120 Park Avenue.

In the 1930s, Michael's College Pharmacy, with its popular soda fountain, became a community focus. An underpass was built to carry Chester Road under the railroad line in 1931. As a result of rebuilding and renovation, the business district reflects mid-20th-century taste rather than its origins in the final years of the 19th century. In its heyday, the business district, storefronts with apartments above, offered all the necessities and luxuries. Today it has an active Main Street program.

While commercial enterprises were discouraged in neighborhoods, especially north of the railroad, there were businesses scattered at different locations. Most prominent was the Strath Haven Inn, but historically there were a few businesses along South Chester Road and Fairview and Yale Avenues.

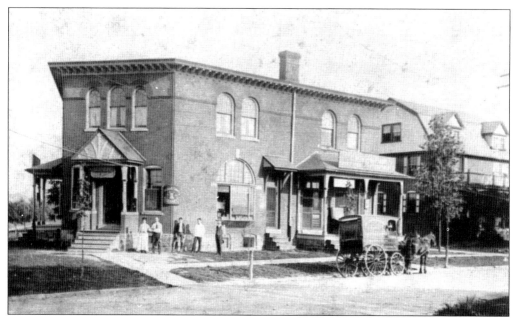

The first business to open belonged to Hannum and Huffnal. They operated a grocery in a store erected for William J. Hall and built by Greim Builders on the southeast corner of Chester Road and Park Avenue. The store opened on November 10, 1892. The building variously housed the post office and other stores. It was demolished in 1925–1926 to make way for the Michael's corner complex.

A week after Hannum and Huffnal commenced their business, Charles A. Smith opened a general store across the street, on the northeast corner. Adelbert C. Lewis was Smith's builder, and George E. Wells of Morton was the architect. The original stone structure has been integrated into the present version of the building. Smith, whose son Aubrey succeeded him, also built the stores at 11–13 Park Avenue in 1919.

The early building next to Hannum and Huffnal on South Chester Road also housed commercial properties. By the early 20th century it had been divided in half with a small bakery addition in front. Today the facade has been extended to the sidewalk but, like many of the stores, the original building is still part of the structure.

This *c.* 1893 view down Park Avenue from Chester Road was photographed from east of Swarthmore Borough Hall. The fountain and landscaped park visible in the middle of the street were located in front of where the Methodist church now stands; they were removed within a few years because of traffic problems. The turret on J. Simmons Kent's house on Princeton Avenue is prominent in the background. (Courtesy Menke and Menke.)

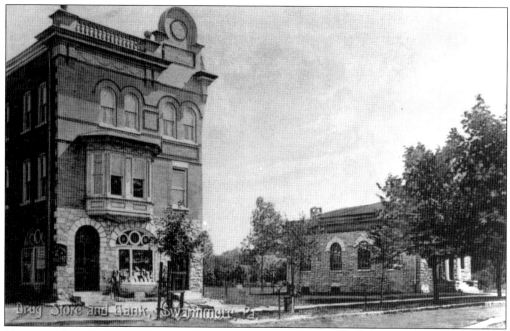

Victor D. Shirer, a pharmacist, erected a drugstore on South Chester Road that was built in two sections. Seen in the postcard above, the first section of this Beaux-Arts commercial building was constructed about 1902. The building on the right is the original Swarthmore National Bank building. The bank was founded in 1904 and opened in 1905. Shirer, who retired in 1947, erected the matching south side of the building before 1920. The roof was united by a single balustrade without the decorative parapet. The postcard below shows the South Chester Road businesses around 1920. (Courtesy Keith Lockhart.)

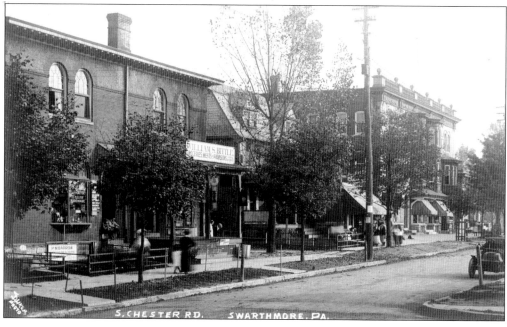

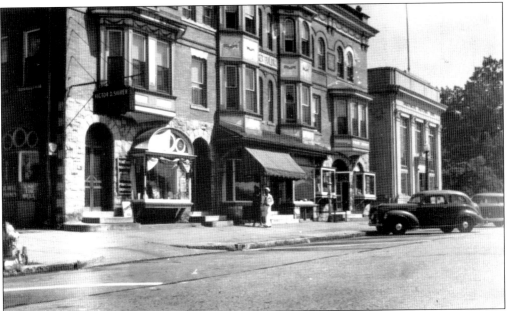

In 1925, the original bank building was moved to Rutgers Avenue to make room for a grander edifice with Italian Renaissance details, shown here with the Shirer Building in the 1940s. The original bank was later demolished. In 1953, Swarthmore Bank consolidated with Media National Bank to become First National Bank of Delaware County, which soon after was absorbed into Provident National Bank.

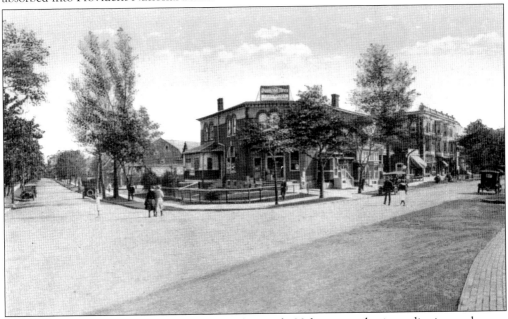

This postcard from the early 1920s is of a bustling early-20th-century business district on the east side of Chester Road, anchored by William Hall's 1893 building. In 1925–1926, the corner was transformed when William A. Clarke and William M. Harvey purchased the properties at the Park Avenue and Chester Road triangle, tore down the old buildings, and erected Tudor-styled commercial structures designed by Stuckert and Company.

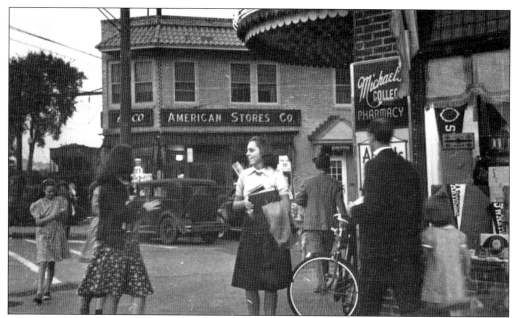

The first drugstore to occupy the new corner store on Park Avenue and Chester Road was owned by B. S. Lebegern. In June 1934, it was purchased by John E. Michael, who gave the store its well-known name, Michael's College Pharmacy. The corner is pictured around 1942. William A. Clarke and William M. Harvey, both Swarthmore College graduates, also developed the homes on Parrish and Magill Avenues in the 1930s.

In this photograph from the 1940s, teenagers enjoy the jukebox and soda fountain that made Michael's College Pharmacy a popular local hangout. The booths and luncheonette eventually were discontinued and other nearby drugstores closed, but Michael's remained the heart of the business district. In 2004, the pharmacy was sold. The current business retains the landmark fuchsia neon sign.

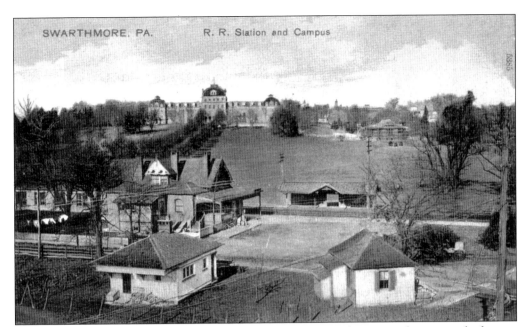

In 1901, E. Clayton Walton joined Henry S. Kent's real estate/insurance business, which soon became known as Walton and Walton, located near the railroad station. Charles M. Smith opened a real estate company next to the Waltons, closer to the station. Both are pictured in this *c.* 1906 postcard, a bird's-eye view looking north toward Parrish Hall with Carnegie Library under construction on the right. (Courtesy Keith Lockhart.)

Unlike most communities its size, Swarthmore has boasted a number of newspapers. The first was the *Swarthmore.* Pictured here is the July 1894 issue, published by the indefatigable John A. Cass. In 1929, the name was changed to the *Swarthmorean,* which continues as a weekly publication. Other newspapers such as the *Borough,* the *Independent,* and a 1905–1906 college press periodical also called the *Swarthmorean* were short-lived.

117

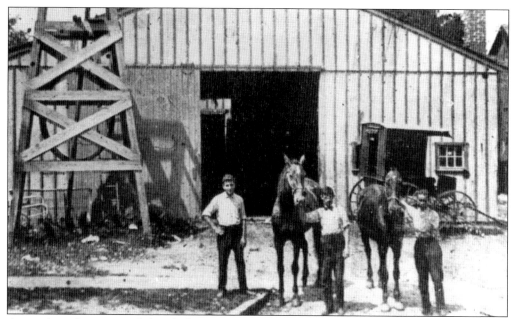

An early ordinance prohibited the construction of sheds or stables on most Swarthmore properties. Livery services carried goods from the station to the college and other locations. In 1884, Ellis W. Yarnall (1857–1941) established a stable that faced the train tracks on what is today Myers Avenue. While operating the livery business, Yarnall also served as postmaster from 1884 to 1925.

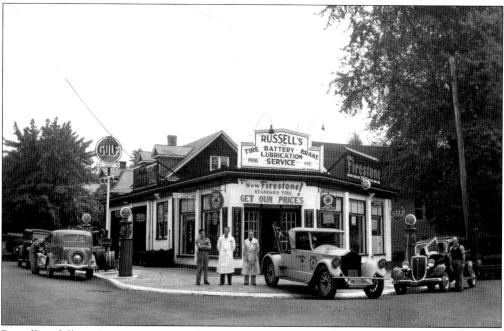

Russell's, a full-service gas station, was located for many years on the triangle of land at Dartmouth Avenue and Lafayette Avenue where the Keystone Bank now stands. Charles R. Russell opened the garage in 1933 and sold the business to Bob Alz, a longtime employee, when Russell retired in July 1949. Alz continued to operate the shop as Russell's Service.

In the 1920s, an automobile showroom and repair shop replaced a livery business on Dartmouth Avenue. The photograph on top shows the Sinclair Garage in 1939 with a sign in its window announcing that it would be the home of the Swarthmore Co-op when renovations were complete. The Swarthmore Co-op was founded as a cooperative fruit and vegetable buying group in 1932, operating out of members' homes. The bottom photograph shows the shops in the same block of Dartmouth Avenue. The store on the left was the Fairlawn, a grocery that later moved to South Chester Road. Next was the Dew Drop Inn, a coffee shop, and beside it was the Co-Op. In 2005, the old Co-Op building was torn down, and the store moved to a new building next door.

Mabel Elms and Leslie Osgood Kurtzhalz established the Ingleneuk Tea House in 1916 at 315 Lafayette Avenue. In 1918, Leslie Kurtzhalz relocated the business to a converted residence at 120 Park Avenue. Except for a brief interlude in the 1980s, the Kurtzhalz family owned and operated the restaurant for over 80 years. Generations of local high school and Swarthmore College students worked at the Ingleneuk, the most famous being author James A. Michener, Swarthmore College class of 1929. A favorite landmark through the 20th century, famous for its butterscotch rolls and reasonably priced home-style food, the Ingleneuk was severely damaged by fire in 2000 and subsequently renovated as a residence and business. The photograph on top shows the Ingleneuk in its prime in 1946. The bottom photograph illustrates its comfortable dining rooms.

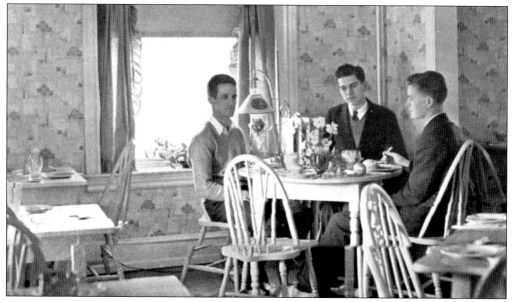

Other small restaurants were located throughout the borough. For example, the Harvard Inn at Harvard and Rutgers Avenues offered rooms for permanent and transient guests as well as a public dining room. The Dew Drop Inn was located in the business district on Dartmouth Avenue. And the Way Side Tea Room operated at 319 Lafayette Avenue, next to the original location of the Ingleneuk.

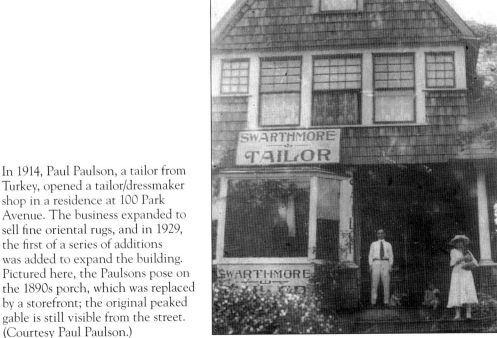

In 1914, Paul Paulson, a tailor from Turkey, opened a tailor/dressmaker shop in a residence at 100 Park Avenue. The business expanded to sell fine oriental rugs, and in 1929, the first of a series of additions was added to expand the building. Pictured here, the Paulsons pose on the 1890s porch, which was replaced by a storefront; the original peaked gable is still visible from the street. (Courtesy Paul Paulson.)

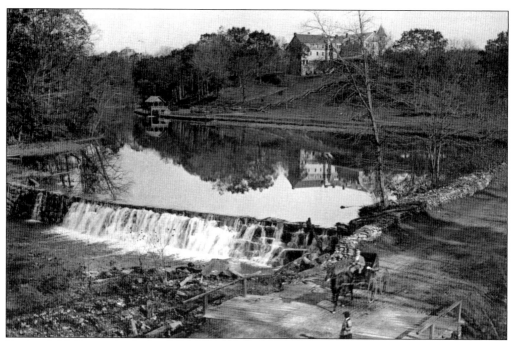

Frederick M. Simons built the Strath Haven Inn in 1892 on Harvard Avenue, overlooking Crum Creek. Simons, who dabbled in real estate, hoped that visitors would be impressed with the pleasant living in Swarthmore and invest in homes. The inn was designed by Samuel Milligan and built by A. C. Lewis in a late Queen Anne style. In 1893, an additional 54 rooms were added for a total of 100. In 1913, the inn was purchased by Frank Sheibley. For nearly 70 years, it was an important social center in Swarthmore, offering activities such as tennis and canoeing as well as year-round dining. The top photograph was taken in 1897 with a view from below the falls. The aerial view was taken around 1930.

The Strath Haven Inn was one of a number of Victorian summer resorts scattered in the Philadelphia suburbs, and it was one of the last to survive. After a damaging fire in 1951, Sheibley sold the property to John A. Dobbs who renovated and modernized it. In 1960, the inn finally closed for good. The building was torn down and replaced by Wildman Arms, now the Strath Haven Condominiums.

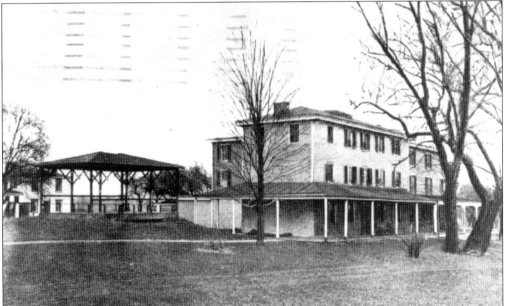

Another resort, although actually more of a boardinghouse, was the Grange, located on the east side of Cornell Avenue, just north of Fairview Avenue. In 1881, Joseph Gilpin, a Philadelphia Quaker, purchased a property from the Sleeper-Horne family that included a farmhouse, tenant house, and outbuildings. The main house became the Grange. In the 1930s, it was said to have been used as a speakeasy, and it was destroyed by fire in 1937.

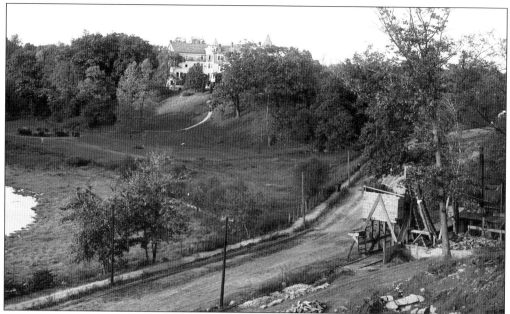

A number of quarries were located in Swarthmore and provided mostly rough foundation stone. Strath Haven Quarry was located above Yale Avenue. The nearby dam and a mill were erected about 1776, and over the years, they produced gunpowder, blades, textiles, and Strath Haven Art Paper. This view of the Strath Haven Inn, photographed in 1903, shows the quarry equipment in the foreground along Yale Avenue. (Courtesy Charles O. Cresson.)

Another quarry, the Ogden Quarry was located at Swarthmore and Ogden Avenues. This photograph, from around 1890, was taken from inside the quarry, looking west toward J. Foster Flagg's house, Quarry Edge, on Elm Avenue. The quarry was used briefly as a community dump and then filled for housing construction. (Courtesy Mary Jane Small.)

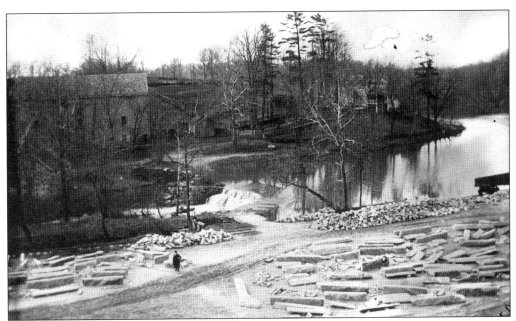

Adjacent to the borough's most southwest boundary was the most famous of the local quarries, Leiper's Quarry along Crum Creek. Leiper built one of the first railroads in the United States to carry his stone. This photograph was taken from the Swarthmore side of the creek, with cut stone from the quarry in the foreground and the Leiper barn across the falls; the Leiper house is mostly hidden by trees.

Many mills operated along Crum Creek, and two were on Swarthmore's borders. The Lewis family operated consecutively gristmill, wood, paper, and, finally, textiles mills beginning about 1778, just south of Baltimore Pike. In the early 20th century, the mill was known as Victoria Plush Mills and produced plush for furniture, curtains, and coats. It closed in the 1940s. This view was taken from Swarthmore. (Courtesy Charles O. Cresson.)

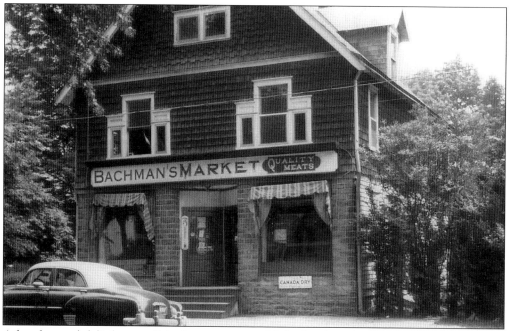

A butcher and deli shop on Yale Avenue was established at least by the early 1920s. Presently home of the Countryside Market, it was operated as a delicatessen by Arthur Bachman and also as a meat market by the Schwartzmans and Ewald van Briesen. This photograph dates to around 1952. (Courtesy John Carrafa.)

The unusual house at 215 Harvard Avenue has an interesting history. Designed by John Torrey Windrim, it was built in 1912 to function as a Bell Telephone Exchange. Operators answered an incoming call and manually connected the caller to the local party. Dial telephone service came to the borough in 1949. The building temporarily housed the Swarthmore Public Library in 1950–1952. Soon after, it was enlarged and converted into a residence.

Hannum and Waite auto dealership was a longtime fixture on South Chester Road and Yale Avenue. Designed in the mission style with Mercer tiles in the parapets, it was built in the mid-1920s as Willys-Knight auto repair and then became a Chrysler dealership. Photographed here in 1931, it was converted into office space in 1988.

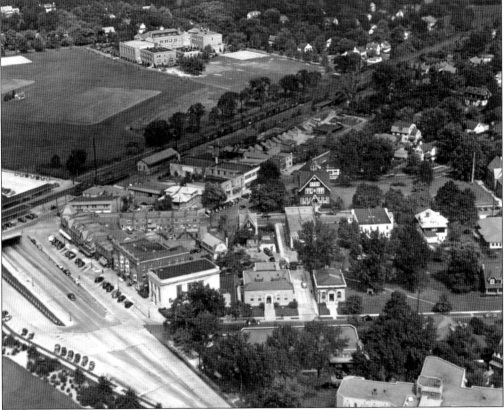

This aerial photograph, taken during the 1930s or 1940s of the business district, shows the old Swarthmore Borough Hall at center with the sprawling complex of the College Avenue School at top. At the bottom right is the Swarthmore Apartments, a cross-shaped art deco apartment building designed by William Macy Stanton in 1930. Not far above is the original bank building, subsequently torn down to make way for other businesses.

ACROSS AMERICA, PEOPLE ARE DISCOVERING SOMETHING WONDERFUL. THEIR HERITAGE.

Arcadia Publishing is the leading local history publisher in the United States. With more than 3,000 titles in print and hundreds of new titles released every year, Arcadia has extensive specialized experience chronicling the history of communities and celebrating America's hidden stories, bringing to life the people, places, and events from the past. To discover the history of other communities across the nation, please visit:

www.arcadiapublishing.com

Customized search tools allow you to find regional history books about the town where you grew up, the cities where your friends and family live, the town where your parents met, or even that retirement spot you've been dreaming about.